JAPAN
IN HISTORY, FOLK LORE
AND ART

BY

WILLIAM ELLIOT GRIFFIS

AUTHOR OF "THE MIKADO'S EMPIRE," "JAPANESE FAIRY WORLD,"
"MATTHEW CALBRAITH PERRY," ETC.

REVISED EDITION

BOSTON AND NEW YORK
HOUGHTON, MIFFLIN AND COMPANY
The Riverside Press, Cambridge

DEDICATED

TO

THE BOYS AND GIRLS

OF

CONSTITUTIONAL

JAPAN

PREFACE.

In this contribution to the Riverside Library for Young People, I have told more about Kioto than about Yedo. I have sketched in outline the Japan of ages rather than of our own age. While political history is the chief theme, my aim has been to show how and why the Japanese see and think as they do. The adoption of Western civilization changes the outer, but does not greatly modify the inner man. Believing also that what the dignified historians write is only part of a people's true history, I have sought, from their customs and folk-lore, as well as from the interpretation of their artists, material with which to brighten the narrative. Fact and fiction, however, are presented in separate chapters.

No writer on Japan can fail to acknowledge deep obligations to that noble band of English students, Messrs. Satow, Aston, and Chamberlain, who have made such profound researches into the

ancient Japanese language and literature. To
them and to Captain Brinkley, the scholarly editor
of the " Japan Mail," I heartily acknowledge
much obligation. To my many Japanese friends
who from time to time assist me, and especially
to the members of the Historical Society of the
Imperial University of Tokio, who have honored
me by membership in their body, I owe much,
and herewith offer my grateful thanks.

It is one of the good signs of the times that
the Japanese are now studying their own history
according to the methods of science, with truth as
the end in view. God speed them!

<div align="right">W. E. G.</div>

BOSTON, Oct. 17, 1892.

CONTENTS.

JAPAN: IN HISTORY, FOLK-LORE, AND ART.

CHAPTER I.

WHERE IS JAPAN?

WHERE is Japan, and how does it lie on the surface of the globe?

With the aid of the steamship and railway, we may answer by saying that Fuji Yama is about sixteen days from New York, or twelve from San Francisco. Or, from the other point of view, we may say that Japan lies in the Pacific Ocean east of China and Corea, in latitude between Newfoundland and the West Indies; that is, the Japanese climate is very much like our own.

Japan is one of the many archipelagoes in the Pacific Ocean. The number of islands under the sun-flag is nearly four thousand. To inclose the space within the ocean-square thus occupied, we must draw our lines on the globe from the point at latitude 50° 56'. Here our pin, or the surveyor's stake, is driven in at the most northern end of a *shima*, for that is the Japanese word for island, called Araito. This land formerly be-

longed to Russia. It is in the old chain or group called the Kuriles, or "The Smokers." Japan from top to bottom is a line of volcanoes. The hot inside of the earth has here a row of vents in the shape of great mountains like funnels turned upside down. From their holes at the top, as out of tall foundry chimneys, gas, fire, smoke and ashes escape from the interior of the earth.

Did you ever see the shell of an *awabi*, as the Japanese call the haliotis, or sea-ear? One may compare the shape and nature of the country to the awabi. The living creature beneath the perforated shell is able through its roof-holes to communicate with the outside world, and make its presence and power known to its prey. The line of apertures reaches along the top from the apex to the bottom level of the shell. So all Japan is a great shell or crust of rock and earth, through which the steam, gas, fire, and lava burst forth at times, just as the tentacles of the awabi leap and twirl through its shell. When, for any reason, one or more of these vents are closed, and the volcanoes become dormant, great earthquakes which twist or wrinkle the skin of the globe, or eruptions, which are boiler-explosions on a vast scale, are sure to happen. Even the rock crust and the granite caps of mountains, unable to imprison the hot subterranean gases, are blown high up in the air.

The little Greek children in old times were

told that Jupiter confined the giants under volca-
noes, and that earthquakes were caused by their
writhing, but the Japanese children think that a
great underground catfish makes the mischief in
their country, and that no one can stop his floun-
dering but the god Kashima.

Since the Japanese, in 1875, exchanged their
half of Saghalin for all the Kuriles, they have
called them Chishima, or the Thousand Islands.

Araito, the northernmost tip of the Mikado's
empire, is a little to the west of Cape Lopatka in
Kamtschatka. To mark the most eastern point
of Japan, we must stick a pin on the map at
longitude east 156° 32'. The Japanese now use
our system of latitude and longitude for survey-
ing and navigation. They are thus able to locate
within a few yards on the great earth's surface
the position of a moving ship or a thatched cot-
tage. Looking through the lines of a spider's
web stretched across the end of a theodolite, they
can measure the precise distance from plumb-bob
to stake-centre, and fix the exact spot over the
centre of a copper bolt driven in the rock. This
mark of the national frontier is in the island of
Shimushu at 156° 32'.

To find the most southerly point of the Mi-
kado's domain, we follow the meridian down to
the tiny island of Haterma, whose tip end south is
at 24° 06'. Close to it the island of Yonakuni
pokes its rocky nose above the waves. Here,

also, on the end nearest Formosa, at longitude east 122° 45', is Japan's most western extremity.

So Japan lies between the Russian territory of Kamschatka and the biggest of the Chinese islands, Formosa. If we inclose the space within the four points we have described, we shall have a quadrangle of over four million square miles; or a little more, in water, of the space occupied by the land comprising the United States. In this ocean surface, however, the actual territory covers only less than 150,000 square miles, that is, about one twenty-sixth of the whole. The land is to the water as one letter in the alphabet. Japan and the two Dakotas are about the same in size, say 150,000 square miles.

Or we may say the Japanese domain looks like a ruler laid slantwise on the map between Kamtschatka and Formosa. In this long and narrow strip, stretching from northwest to southeast between the Russian and Chinese territory, the space, roughly measured, is twenty-two hundred miles long and five hundred miles wide, and the land occupied is one seventh of the space.

On most of our school maps of Asia, the Japanese Archipelago is represented as, relatively, about the size of a caterpillar lying on the pumpkin of Asia. Or, if Asia be a ship, Japan is the rudder. Indeed, glancing from north to south, we may thus make an appropriate picture, in our mind's eye, of this land of tea, silkworms and

silk. We may look upon the rounded coast of China as a great teapot, with its spout pointing towards the headless butterfly or silk-moth of Corea; while the mainland of Japan appears as a monstrous silk-worm with its head at Kiushiu, spinning out of its mouth a great, glistening thread of islands stretching down to Formosa. Indeed, while the literal meaning of the name Riu Kiu is "sleeping dragon," the native name is Okinawa, or "long rope."

In the geological ages of the world, there was probably an extended causeway of land or mountain ridge from Kamschatka to Formosa. By the action of the ocean waves, continued during long ages, this ridge has been broken into large and small islands. Along the whole eastern length of the empire there rushes like a millrace a river of indigo blue in the sea. This is the Kuro Shiwo, or the black current, which flows from the Philippine Islands past Japan and across to North America. With the first peopling of Japan, and possibly of our continent, this ocean-river had, as we shall see, something to do.

Here, then, is a country stretching between the Tropic of Cancer and the latitude of Labrador, with most of its people crowded in the parallels that include the region between New York and Florida. The people are civilized, polished in manners, with writing, arts, literature, a long history, and a dynasty or line of emperors older than

any succession of rulers on earth, unless possibly that of the popes. They have a written constitution, representative government, and the modern appliances of war and peace, with steam engines, electric telegraphs, printing presses, and many other modern things. They now look into a future which they expect to share with Europe and America. They no longer turn to China for ideas and principles. Having entered the brotherhood of the nations of Christendom, the Japanese is the most promising of Asiatic peoples.

In our day and generation Japan has shot into notice like the flowering century-plant among the nations. Within the memory of young men now living, the country seemed as closed, inactive, repellant, and unpromising as the fat and thorny-leaved aloe, that quietly stores up starch within and prickles without. Now, having burst into splendid bloom and captivating color, and its inner riches revealed, Japan charms the world.

We have answered the question, Where is Japan? in the terms of geography and astronomy. If now we ask the Japanese poets the same question, they will reply that theirs is the Country Between Heaven and Earth, the Land Where the Day Begins, Sun-Rise Kingdom, House of the Morning, Sun Land, Sun's Nest, Country Within the Boundaries, or Kingdom of Peaceful Shores. These are the names found in Japanese poetry and romance.

As for the shape of it, they tell us it is the Country of the Eight Great Islands, the Dragon-fly Kingdom, the Outspread Islands which remind one of the stepping stones in a garden-path, the Castellated Fortress Island, Fertile Plain of Sweet Flags, the Beautiful or the Princess Country. Politically, Japan is the Mikado's Empire, or the Country Ruled by a Dynasty of Heavenly Rulers.

CHAPTER II.

WHO ARE THE JAPANESE?

WHEN the imperial census-takers completed their count on the 31st of December, 1890, it was found that there were 40,072,000 people in Japan. We must think of them, the Japanese, as a nation numbering over forty millions.

Three fourths of the inhabitants live on Hondo, or the main island. Of the remainder, five millions, or over one eighth, dwell on the next largest island, called Kiushiu, or The Nine Provinces. In Shikoku, the Island of the Four Countries, live about three millions. The northern islands, called the Hokkaido, or Northern Sea Circuit, are not so thickly settled, for in them all together we find only a third of a million of souls.

In the old way of enumeration, they made a rough census by counting houses, or smoke-holes in the roof, reckoning five people to a house. Now, and since 1872, they count noses, and souls. There are nearly eight million houses, and they, like the people who live in them, are mostly thickly massed in central Japan. Here, where the soil is fertile, the climate good, and the country has been long occupied, we find towns and

villages as close to each other as beads on a
rosary, while the cities are large and numerous.
In Yezo, however, one may travel many leagues
through the country without seeing either house
or man. On every square mile of central Hondo
there are four hundred and sixteen people, but
in the islands of the Northern Sea region only
seven. The average for all Japan is two hundred
and sixty-six, which makes this eastern empire
about as well filled with people as Italy, but not
so thickly populated as China proper. There is,
however, plenty of room in Japan for more peo-
ple, since the ratio of inhabitants to the square
mile is nearly one half that of Belgium or Sax-
ony.

Fifty per cent of the population are farmers,
and live in villages and hamlets. No matter how
far away the fields which they cultivate are from
their homes, the countryfolk dwell in houses
which are grouped together, and a farmhouse
standing by itself is rarely seen. After the agri-
cultural classes, in numbers, come the trading
people, and next the mechanics.

The people are divided into three grades, —
nobles, gentry, and commons. The two upper
classes comprise two millions, while the common
people number thirty-eight millions. All subjects
of the Emperor have equal rights before the law;
but this has been the case only since 1889, and
under the new constitution. The Eta people, who

numbered half a million, and were once looked upon as outcasts, and not better than beasts, are now citizens. Even the Buddhists did not admit the Eta to religious privileges or membership. One honorable exception was seen in the Shin sect, whose priests and people, to their everlasting honor, treated them fairly.

Up in the north, in Yezo, there are about fifteen thousand aboriginal people called Ainu, who have bushy beards and hair and straight eyes, like Europeans.

In the Riu Kiu islands, in the extreme south, the people are a little different from most of the Japanese, and the language they speak is not so correct or polished as that of the people on the large islands. All these are subjects of the Mikado. Excepting the Ainu speech, there are not those variations in the language, as spoken in all the four thousand islands of the empire, which are found in China. Properly speaking, there are no dialects.

The Japanese are quite different from the Coreans and Chinese in stature and appearance. A thousand people suddenly gathered at random from the streets of Seoul or Peking, and a thousand gathered in London and New York, would probably show averages of stature the same. The Japanese, however, are not so tall as people in America and Europe. They are undersized; the average height of the men is 5.5 feet, and that of

the women 4.5 feet; but among the mountaineers, boatmen, and occasionally in the cities, one may see a man six feet or over in height; while the wrestlers are gigantic in size and weight. All varieties of fat and lean people are noticeable. The children are usually plump and rosy-cheeked. The boys are active, and the young girls pretty.

Some one has called the Japanese "the diamond edition of humanity."

Unfortunately for the Japanese, he is not proportionally developed, yet the cause of his short stature may be removed. The upper half of his body is of proper length, but the lower portion is shorter than it ought to be. In perfectly formed human beings — and indeed in the average — the measurements up and down from the centre of the body are the same. Not so with the inhabitants of Dai Nippon. In the Japanese army, of twelve hundred men measured by the surgeons, it was found that there was a difference of over an inch between the upper and the lower parts of the body.

The doctors say that, besides improper or badly cooked food, the chief cause of shortness in the lower limbs is the custom of sitting long on the knees and heels. Until recently, chairs, sofas, stools, and rockers were unknown in Japanese houses. People carried their sitting apparatus with them, as snails are said to travel with their houses on their backs. They made folding chairs

out of their legs by using their hams and their
heels, tucking their feet under them. Beginning
in their childhood, they were able, even when
grown up, to sit for hours in this position without
having their legs go to sleep. In this way, and
in the lapse of ages, the circulation of the blood
in the lower limbs becoming more or less stag-
nant, the legs of the whole nation perceptibly
shortened.

The Chinese bind the feet of their women in
order to make them as small as the hoofs of a
gazelle. The Japanese have never practiced foot-
binding; yet without knowing it they have been
shortening their legs, and subtracting the fraction
of a cubit from their stature.

When foreign people go into the houses of the
Japanese to visit them, they politely try to sit
down on their knee-bones and ankles. Pretty
soon they have to give it up, apologize, and then
stretch out their legs ungracefully on the matting.
They invariably fall asleep at the wrong end.
While their heads are wide awake, their feet will
not wake up. Nowadays the people put some-
thing between themselves and the floor. The
fashion of furnishing the house with chairs, set-
tees, and high tables is increasingly common.

In thinking of Japan and the Japanese, one
must not think of China and the Chinese. The
two countries and people are too widely different
in many ways to be compared. China is ten

times larger than Japan, and her area greatly
exceeds that of the United States and Alaska,
while all the territory of Japan is not very much
more than half of our one State of Texas. The
Chinese empire has probably ten times as many
people as the Japanese. China has an older civi-
lization and has been more original, Japan being
for centuries the pupil of the Middle Kingdom.
The tongues of the two nations have little or no
connection with each other. In language, cus-
toms, government, history, character, and temper-
ament, the two people are quite as different as
are Russians from Englishmen.

The Japanese do not smoke opium, do not bind
the feet of their women, nor wear queues or "pig-
tails." They seem to be in mind half way be-
tween European and Asiatic people. Perhaps
their greatest work and most brilliant career are
yet before them. The Japanese seem called upon
to reconcile Eastern and Western civilizations, to
interpret to Asia the meaning of European ideas
and institutions. Many wise men think the Pa-
cific Ocean is yet to become the arena of the
greatest triumphs of the human race, as the Medi-
terranean once was, as the Atlantic is now. If
so, since Japan holds the key of the Pacific, her
future may be far more brilliant than the past.
Certainly the promise to the Sun-land is that of a
new sunrise.

The Japanese do not lack in reverence for

their own country. To them it is the Honorable
Realm, the Land of the Gods, the Country of the
Holy Spirits, the Kingdom that Endures for Aye,
the Everlasting Great Japan, created first of all,
and rising out of the waters of chaos; they call
the oldest part of their beautiful land the Island
of the Congealed Drop. Of this we shall read in
their own story of creation.

CHAPTER III.

THE MORNING OF RISING-SUN LAND.

LYING out in the ocean, at the ends of the earth from Europe, and, in the day of small boats, far enough from China, and near only to Corea, by whom was the land we call Japan first discovered?

Savages who have no letters, and therefore make or keep no written history, cannot tell their own story, or remember the time when anything long ago happened. Even their traditions are usually worthless after a few generations. They melt away like dream stuff into the infinite azure of the past.

Who were the aborigines, or the people who lived before history was written, in Japan? Who came first of all into the lonely islands in which no baby had yet cried? This question even scholars cannot now answer.

Most probably they were men of the Malay race who drifted up from the south. From Formosa, or still further below in the Philippines or the Malay Archipelago, there is the swift, dark-colored river flowing in the ocean called the Kuro Shiwo, of which I have already spoken. Even

without sails or oars, but by simply floating in
this great Gulf Stream of the Pacific, men could
reach southern Japan. Perhaps, during as many
centuries as the present world counts in her age,
this stream has been gradually peopling Japan as
well as America. Many things indicate that the
Japanese have Malay blood in their veins. Many
of their ancient customs, their tattooing, their
dances, their comedies and mask entertainments,
their superstitions and methods of war, their an-
cient head-hunting raids, point to a Malay origin.
Certainly the Japanese are a mixed race.

Another strain of aboriginal blood flows from
the Ainu, who once inhabited central and north-
ern Japan. Dark-skinned, more or less hairy
in their bodies, straight-eyed, bushy-haired, they
were hunters and fishermen. Though now a mere
remnant, living in Yezo as mild and peaceable
savages and bear-worshipers, they once bravely
resisted the Japanese, who by degrees conquered
and subdued large masses of them within the
boundaries of the empire. In time they have
become peaceable tillers of the soil, and good
subjects of the Mikado. The native histories
show that as the Japanese waves of conquest
pushed farther north, just as the white man
pushes the Indian before him, the free Ainu were
raiding savages. They plundered the civilized
farmers and destroyed their houses and crops,
only to be conquered and reduced to quiet obedi-

ence to the laws. In this way, all the Ainu of Hondo in time became, by mixture of blood and the arts of civilization, true Japanese.

To this day the Ainu names of the lakes, rivers, mountains, and great landmarks, from the Strait of Tsugaru down to Kioto, linger beneath the later Japanese terms. An American child can read all over the United States, and even in the place of the original thirteen colonies, the Indian names of places long since occupied by our fathers. As before Boston was Shawmut, and before the Hudson River was Shatemuc, and behind Salem was Amoskeag, so under the pronunciation of the Chinese characters and Japanese names we find the tell-tale Ainu word. Before ever a man with a hair-pen, and with "India" ink rubbed up with water on a stone, began on mulberry or bamboo paper to write the letters spelling Fuji Yama, the Ainu had named it the Throne of Fire.

The Ainu probably came into the Japanese islands from the north, where the mainland and Saghalin are quite near each other.

Still further yet, in this England of the East, before some Asian William the Conqueror came over from the Normandy of Corea, were still other folks than Malay and Ainu. Between Corea and Kiushiu, there are islands which are like stepping-stones to help boatmen from sunset to sunrise. This is just where the southern points of the two countries bend nearest each other. On

the Sea of Japan, as we go further north, the
coast lines of the two kingdoms become concave
and get farther apart, until, near the southern
point of Siberia, they again approach. The
current, which on the ocean side sweeps northward
past Japan, flows on the Asian or Corean side
southward. This would make easy passage for
the Highlanders, or seacoast men of Manchuria,
who pointed their prows southeastward towards
the land over which the sun rose and morning
broke.

So, by sailing straight toward the rising sun,
both the southern Corean and the northern Tartar
would easily reach Japan. Long before they set
foot on shore, they would see the green mountain
wall over which the sun rose. No wonder they
called the new land Nippon, sun-root or sunrise;
more fully, Nihon Koku, or Country Over Which
the Sun Rises. Yet even these are names which
began to be used only after Chinese characters
came into use in Japan. Most ancient is the
pure Japanese, Hi-no-moto, which means The
Root or Source of the Light, or The Country
where the Day Begins. No realm has so many
names as the Mikado's, or names more beautiful;
but the oldest of all, variously pronounced, points
to the lips of a people coming from the west.

These Coreans and other Asiatic mainlanders
settled along the coast of Kiushiu and of Hondo,
at Idzumo, at Wakasa, and in the land bordering

these great bights in the coast, near Oki Island
and at Tsuruga Bay. Here is the heart of the
country, and the key of Japan. The centre and
narrowest part of the main island is along the
coast of Wakasa. It is a place in Japanese his-
tory like the "Saxon Shore" in Great Britain.
As on the sand of the English strand so often
gritted the keels of the Angles and Saxons, so
here the Asiatic men from the west beached their
boats.

Then began the delights of hunting and war in
their new home, until they were well scattered
throughout the area of the islands. Probably in
their numbers, influence, methods, and results of
conquest, they were much like the Saxons. While
many of the aborigines of Malay and Ainu blood
were slaughtered, the majority were spared, and
large intermixture by marriage took place. Lan-
guage and customs were modified, and became
more uniform. Probably until near the time of
the Christian era, the people were almost entirely
hunters and fishermen, and tribal wars rather than
peace were the rule. This was the stone age of
Japan; and its relics in the form of arrow heads,
and rude tools and patterns, and shell heaps, can
be found as often and as easily as in America.

Now, among these piratical or colonizing expe-
ditions, which at various times came from the
Asian mainland, was one of special interest to us.
For this we must look much further to the south.

Across the bay from the province of Satsuma, in which the pretty crackled and decorated pottery is made, is the province of Ozumi. Here, probably, one set of invaders landed and grew to be a powerful tribe. After several generations and many victories, these brave people began to expand their domain. Starting out to conquer all Kiushiu they succeeded, and then, reaching the region of Osaka by boat, they established themselves in the centre of Hondo. The province now called Yamato became their seat of government. They rapidly reduced the surrounding tribes to submission, and, before many generations had passed, the centre and southwest of the archipelago was under their nominal control.

The men of this clan or house of Yamato were not only very brave and capable, but they were better disciplined, and had superior war material and resources. It is probable, also, that their weapons were of iron, while those of their enemies were of copper, bone, and shell. The Yamato men cultivated the soil, and could thus lay up large food supplies, while the men they conquered depended wholly upon hunting and fishing.

We now know another secret of the success of the Yamato men. It lay in the superiority of their religion, or possibly their craft in the political use they made of it. It is not likely that they possessed writing, but they had a liturgy

or ritual. They worshiped their ancestors, and made gods of their most famous or useful men when deceased. The man who made farming more successful, the earth more fertile, or who introduced a new article of food; or the one who skilfully healed diseases or averted a pestilence; who invented pottery, or a more effective tool or weapon, or a new utensil or decoration, — was honored during life, and after death was worshiped. To their chief they paid something like divine honors even when living. His house was a temple, or sacred dwelling place, which they called a Miya, and its occupant Mikado, or Awful Habitation. Possibly, however, the word "Mikado" means Honorable Gate, for in Japan the gate is often nearly as magnificent as the house. In this, these primitive Japanese were like their Tartar relatives, the Turks, who call their government, after the palace entrance, the Sublime Porte. So, also, the Egyptians spoke of their ruler as Pharaoh, which probably conveys the same idea. We all know that the Iroquois Indians were Men of the Long House.

These Yamato men employed religion as a help to complete conquest. They captured, as we may say, the beliefs of the islanders, whom they conquered, by coupling on to the aboriginal cult their own theory as to the origin of themselves, their ancestors, their chiefs, and the Mikado. Like a locomotive that draws after it a long train

of freight cars, so the Kami or Mikado religion drew to and after it all else in the country.

Thus, making an engine of their doctrine for crushing their enemies and riveting their chains, they taught that they were descended from the heavenly gods, and that their ancestors had originally come down from heaven. Their Mikado being a son and representative of the celestial deities, all men must obey this Son of Heaven, or suffer death. The subdued people were taught that their ancestors were only earth-born kami or gods. The earthly gods must obey the heavenly, and their children be loyal to the Mikado. Both by their fierce soldiers and by their teachers and priests, by better weapons and fighting and superior dogmas, the Yamato tribe became the chief of all Japan. To this day, the people call their emperor Tenshi, or Tenno, which means Heavenly Son or King.

The Mikado and millions of Japanese still worship their ancestors, and believe the ancient mythology. In the proclamation granting the constitution and houses of Parliament, June 11, 1889, the Mikado, after first, in the sacred shrine in the palace, worshiping the spirits of his Yamato ancestors, said : —

" We, the successor to the prosperous throne of our predecessors, do humbly and solemnly swear to the Imperial Founder of our House, and to our other Imperial ancestors, that, in pursuance

of a great policy coextensive with the heavens and with the earth, we shall maintain and secure from decline the ancient form of government.

" We now reverently make our prayer to them and to our Illustrious Father, and implore the help of their sacred spirits, and make to them solemn oath never, at this time or in the future, to fail to be an example to our subjects in the observance of the law hereby established.

" May the Heavenly Spirits witness this our solemn oath ! "

Even the political party in opposition to the government, called the Kai-shin-to, in the spring of 1892, while urging more liberal measures looking towards democracy, thus made profession of the religion of loyalty to the emperor : —

" We firmly believe that these deeds [the reforms since 1868, and introduction of many features of Western civilization, most of them the direct outgrowth of Christianity] were accomplished by the spirits of the departed emperors, and by virtue of the reigning sovereign."

The seat of power of a country is called the capital, but in Japan the *miako* or *kio ;* a word we see in Kioto the old, and Tokio the present capital. In the early days, however, when superstitious fears made people dislike to live .in a house in which a person had died, the Court, or Mikado's residence, was often changed. It was easy to put up new houses when these consisted

of wood, without nails or paint, thatched with
straw, and tied together with creeper-vines. So
each new Mikado made for himself a new capital.
The region called the Gokinai, or five home prov-
inces, is the old homestead of the Japanese nation.
This region is full of places once called capitals.
Now the sites are only hamlets. In some cases,
like those of the great Iroquois Indian towns of
the Mohawk valley, they are only names. Japan
has had in all nearly sixty capitals.

Nara was the first to keep unchanged during
the reigns of no fewer than eight imperial rulers.
Possibly the fact that four of these were women
had something to do with such permanence, which
was then a novelty. More probably, the civiliza-
tion then being imported from Corea and China
influenced the new policy making settled life
seem more civilized and respectable. After Nara
had served as the capital from A. D. 709 to 784,
ten years of wandering followed, and then Kioto
was chosen. From 794 until 1868, the Mikados
resided in this city; then Yedo was chosen the kio,
and named Tokio or Eastern Capital. Only in
our day have the wonderful art treasuries of Nara
been opened, and their contents been studied.

One hundred and twenty-three Mikados have
sat on the throne of Japan, but those who reigned
before the days of almanacs, clocks, and written
records, were not like the ordinary kings or people
of history. These prehistoric Sons of Heaven

were seventeen in number. They usually lived
to extraordinary ages. All except four died at
ages varying from one hundred to one hundred
and forty-three years. As some of those most
early in the line were born of dragons or sea-
monsters, and behaved just as people do in fairy
tales, it is probable that their ages, their reigns,
and their personalities are uncertain. We can
be pretty sure that the idea of giving to each
reign of the seventeen Mikados an exact date
and length occurred to the imperial scribes and
almanac-makers about a thousand years after the
first Mikado is said to have ascended the throne.
The date of the beginning of the Japanese em-
pire, that is, 660 B. C., was not officially fixed
until 1872, when the Chinese system of counting
time was discarded for that in use in Europe.
The thousand years or so before the eighteenth
Mikado have little value as history.

Thus far we have looked at the story of the
peopling of Japan and the rise of the Mikados
as a cold-blooded foreigner may. We have told
it in prose, but not so do the Japanese look at
it. To them it is all poetry, lovelier than a fairy
tale; while, until recently, to most of the common
people, it was their religion. Let us now hear
the pretty tale as the oldest books, written over
a thousand years ago, tell it, and as it appears
in poem, picture, bronze, ivory carving, and the
whole wonderful art of Japan.

CHAPTER IV.

THE JAPANESE STORY OF CREATION.

In the beginning, heaven and earth were not yet separated. Chaos, enveloping all things like an egg, contained a germ. The clear, airy substance expanded and became heaven, the heavy and thick part coagulated and became the earth. Then the young land floated in the water like oil, and drifted about like a jelly-fish. Out of this warm earth sprouted a bush-like object, from which were born two deities, Pleasant-Reed-Shoot-Prince-Elder-God, and The Deity-Standing-Eternally-in-Heaven. After these heavenly deities seven generations of gods were born. Their names are The Deity-Standing-Eternally-on-Earth, Luxuriant-Thick-Mud-Master, Mud-Earth-Lord, Mud-Earth-Lady, and others with very long names, usually ending in the word *mikoto*, which we translate " augustness."

These kami or gods, though in pairs called a generation, were each single and had no sex; but the last two of the series were Izanagi and Izanami, and their names mean The-Male-Who-Invites, and The-Female-Who-Invites.

After these seven divine generations had come

into existence, all the heavenly gods, granting to
Izanagi and Izanami a heavenly jeweled spear,
commanded the pair to make, consolidate, and
give life to the drifting land. The two gods
stood on the Floating Bridge of Heaven, and
Izanagi pushed down the jeweled spear and
stirred the soft warm mud and salt water. When
the spear was drawn up, the drops that fell from
it thickened and formed the Island of the Con-
gealed Drop. In common geography, this island
is Awaji, at the entrance of the Inland Sea.
Upon this the two gods descended, and, planting
the jeweled spear in the ground, they made it the
central pillar of a palace. They then separated
to walk round the island; when they met, Iza-
nami, the female god, cried out, —

"How lovely to meet a handsome male!"

Izanagi was offended that the female had spoken
first, and demanded that the tour round the island
be repeated. Meeting the second time, Izanagi,
the male god, spoke first and cried out, —

"How joyful to meet a lovely female!"

Thus began the art of love.

Then followed the creation of the various islands
of Japan, and all the gods who live on the earth
and are called the earthly deities. These earthly
gods married among each other, and from them
were born many good things, such as rice, wheat,
millet, beans, sorghum, and other articles of food.
Gradually the earth was filled with trees and

plants and beautiful objects, as gems and shells and waves.

Down below the earth was the Land of Roots, or Home of Darkness. Izanami, when offended at her husband, fled into this place, and died in giving birth to the god of fire. Izanagi had to go after her to win her back. He found it a region of awful foulness, and his wife a mass of worms. Rushing out, he washed himself in the sea, and from the rinsings were born a great many evil gods. These trouble the good gods, and vex and annoy mankind. But out of his left eye was born a beautiful maiden whose body shone brilliantly.

At this time the heaven and earth were close together, united by a pillar. Going up this pillar into heaven, Izanagi's beautiful daughter became the sun, or the Heaven-illuminating Goddess. Izanagi's son became the moon, and was commanded to rule the blue plain of the sea and multitudinous salt waters. The names of these two are Amatérasŭ and Susanoö.

As the earthly gods and evil deities multiplied, and confusion reigned on the earth, the Sun Goddess, or Heaven-illuminator, resolved to send her grandson Ninigi down to the earth to rule over it. She gave him three precious treasures, — a mirror, the emblem of her own soul; a sword of divine temper, which her brother had taken from the tail of an eight-headed dragon which he had slain; and a ball of crystal without a flaw.

Great was the day when a mighty company of gods escorting Ninigi marched down out of heaven, and, on the Floating Bridge of Heaven by which the two heavenly gods had first descended, came down to the earth. Reaching the top of the great mountain Kirishima, which lies between Satsuma and Hiuga, they descended into the wild regions of Japan.

Ninigi began at once to reduce the earthly gods in order, and maintain good government. Heaven and earth now grew wider and wider apart, and at last separated, so that communication was no longer possible.

The sons of Ninigi were named Princes Fire Fade and Fire Glow. While fishing, they had a quarrel, and Prince Fire Fade went down beneath the sparkling ocean waves to Riu Gu, the palace of the Dragon King of the World under the Sea; there he married the King's daughter, the Jewel Princess. After a time spent in the under-sea world, the Dragon King, or Ocean-possessor, sent Prince Fire Fade back to earth on the back of a crocodile, armed with the jewels of the ebbing and flowing tides. With these he was able to cause or to quell a flood of waters. He raised one that threatened to drown the whole world, and then his brother Prince Fire Glow behaved himself. Prince Fire Glow begged pardon and became the servant of his brother who possessed the wonderful tide jewels.

Prince Fire Fade now built a hut on the sea-
shore, and roofed it with cormorant wings. Here
was born the child that became Jimmu Tenno,
the great-grandson of the Sun Goddess, and the
first Mikado of Japan. Prince Fire Fade, filled
with curiosity, ventured to peep into the hut
roofed with cormorant wings. There he saw only
a crocodile eight fathoms long, which crawled into
the sea, and plunged down to the Dragon King's
palace far below.

The child thus born of a sea monster grew up
to be a great warrior, and after many years'
conquest made himself master of the island now
called Kiushiu. One day, on coming to the edge
of the sea, he saw a tiny little earth-god riding
towards him in the shell of a tortoise, raising his
wings as he came. Knowing the sea-path, he be-
came Jimmu's guide to Naniwa, near the place
now called Osaka. On landing with his army
and fighting the enemy, the brother of Jimmu
was mortally wounded in the hand by an arrow.

Ascribing this calamity to the fact that they
had marched against or in the face of the sun,
they turned and made their way round the south-
ern side, with their back to the sun. Meanwhile
the heavenly gods came to Jimmu's aid, and
dropped a sword of divine temper through the
roof of a storehouse owned by a native of the
region. He brought and presented it to Jimmu.
Before this sword the enemy fell down. The

heavenly gods also sent a crow eight feet long to guide the army. Many earthly gods, ancestors of tribes, now submitted themselves to Jimmu. At a great cave eighty earth-spiders were hiding, which he attacked and killed. So, having thus subdued the savage deities, and extirpated the rebellious people, Jimmu built a palace at Kashi-wabara, the oak moor in Yamato. There he married the princess Ahira. Jimmu died when one hundred and thirty-seven years old.

Thus began the dynasty of the emperors of Everlasting Great Japan, "unbroken from ages eternal."

CHAPTER V.

ORIGIN OF THE ARTS.

THERE is no greater favorite with artists, dancers, musicians, and the people generally than the story of the laughing goddess Uzumé. She it was who by her funny tricks enticed the Sun Goddess out of the cave. While in her hiding-place, all faces were black with gloom, and every-thing was plunged in darkness. When Uzumé drew her out, everybody and all the world was *omo-shiroi*, "white-faced."

Susanoö, the ruler of the moon, is also called, in the sacred books, His-Swift-Impetuous-Male-Augustness. He was a very mischievous fellow. His sister was the lovely Sun Goddess. She is also called the Heaven-Shining-Great-August-Deity. Wishing to beautify the land, she had made rice-fields, caused irrigation ditches to be dug, and a palace to be built. Her naughty brother Susanoö broke down the earth walls between the rice-fields, filled up the ditches, and threw mud in the palace where the Sun Goddess ate her food. His sweet-tempered sister excused and apologized for him, but he kept on playing his vicious pranks. One day he caught a spotted

horse and skinned it alive. He then climbed up
the roof of the house in which the Sun Goddess
and her maidens were weaving garments for the
gods. Breaking a hole through the thatch, he let
the reeking carcase of the animal fall down over
the looms among the weaving-women, who were
dreadfully frightened and injured. The Sun
Goddess hurt herself with the shuttle, and was
so terrified at the sight that she ran into a cave
and hid herself. She fastened the rocky door so
tightly that all heaven and earth at once became
dark as night. At this, the wicked gods began
to behave very uncivilly, and buzz like flies in
the month of June. Besides this, there were ten
thousand dreadful signs of coming woe.

Then the eight hundred thousands of gods
assembled together in the dry bed of the River of
Heaven. There they took counsel, and summoned
the god named Thought-includer to help them.
This wise god, who included in his single mind
the cogitations and contrivances of many heads,
they ordered to think out a plan to entice the Sun
Goddess from her cave. Thereupon he brought
together those long-singing birds of perpetual
night which we call cocks, and bade them sing,
that is, to crow. Taking hard stones to make
a forge, harder rock for an anvil, and iron out
of the heavenly metal-mountains, he called the
heavenly blacksmiths and set them to work. He
ordered a mirror to be made. One god was

charged with the making of a string of five hundred curved jewels, eight feet long. Two other gods of long name were ordered to pull out the shoulder blade of a stag from Mount Kagu. Heating the bone in a fire of cherry bark, they were to watch the cracks, and to draw omens. A *sakaki*-tree with branches was pulled up by the roots to serve as a wand for the laughing goddess Uzumé. On the upper branches were festooned the curved jewels. On the middle branches was hung the great star-shaped or eight-pointed mirror. On the lower branches were suspended the white and blue peace offerings of cloth and hemp. His Augustness-Grand-Jewel held these, while His Augustness-Heavenly-Beck-oning-Ancestor-Lord offered prayers and recited the ritual. The Heavenly-Hand-Strength-Male-Deity stood hiding near the rock door, ready to pull it open whenever the Sun Goddess should peep out.

Uzumé, the laughing goddess, who is also called Her Augustness-Flaming-Female, made a sash of club moss to hang round her. Her head-dress was a heavenly spindle-tree.

Binding the leaves of the bamboo grass into a bouquet, and thus arrayed, she stood on an inverted tub or trough. This, as she danced, resounded like a sounding-board. Loosening her clothes, and acting in the funniest way, as if possessed, even the gods could not keep their

faces straight. They all burst out into roars of laughter, and the high plain of Heaven shook.

All this so amazed the Sun Goddess in the cave that she could not restrain her curiosity. Opening slightly the rocky door of the cave, she peeped out to see what was going on, and to ask what all the gods were laughing at. Then Uzumé cried out: " We rejoice and are merry because there is a deity more illustrious than thine augustness." While she was saying this, two of the gods pushed forward the great mirror. When the lovely daughter of Heaven saw herself for the first time, astonished at beholding so beautiful a face and form in it, she gradually came further out of the cave. Then the Heavenly-Hand-Strength-Male-Deity, who was hiding in the shadow, took hold of her hand, and the Grand-Jewel God drew a rice-straw rope along behind her back. At once all the heavens and earth were full of light once more and gladness reigned. Susanoö, the brother, was punished by being driven into exile.

Now all this pretty story shows that the gods who are described in the Kojiki were genuine Japanese and lived in Japan. The River of Heaven is exactly like those rivers in Japan which have a dry, pebbly bed, splendidly suited for picnics and dances, except during times of flood. Susanoö is the small boy who teases his pretty sister to-day, as he teased her a thousand

years ago. Amatérasŭ, or the Sun Goddess, is
one of those lovely, modest Japanese girls who
are so charming, industrious, and beautiful at
the age of sweet fifteen. Even the gods of the
Kojiki are exactly like the folks we know who
live under the bamboo and camphor trees. Many
an Uzumé still giggles, simpers, and dances,
and many a strong-handed fellow still tries his
strength; while all the cunning craftsmen in the
various trades love to see, in the founder of their
particular business, one of the gods who enticed
the Sun Goddess out of the cave.

It may be, also, that this pretty story of the mis-
deeds of the Moon God and of the Sun Goddess
points to astronomy. One Japanese author says
it is only a poetical way of describing an eclipse
of the sun. The wicked gods who buzzed like
flies are the rebellious aborigines not yet so fully
subdued. They always liked to make trouble
with the Mikado's officers. The crowd of deities
who assembled in a great host are the conquerors
of the country, the gods with specially honorable
names being the chiefs and leaders. The clever
men and inventors called on to show their skill
were the first mechanics, inventors, and engineers.
Uzumé, who showed her powers of amusement, is
the patron of comedy.

When the story is told in all its particulars, we
see that it explains many things in a poetical
way. It shows why the sun is feminine and is

spoken of as a lady, while the moon, instead of
"that orbed maiden, with white fire laden," is a
rascally male fellow. It pictures the first inven-
tion of weaving and clothes, iron-working with
bellows made of the skin of a deer, and anvil of
bare rock. Two gods, the first carpenters, dug
holes in the ground with spades, erected posts,
and built a palace. Other gods made a necklace
of the curved jewels, or *magatama*, out of car-
nelian or soapstone. They added hairpins and
bracelets, with head-dress of gold and silver, and
thus became the first jewelers. The mirror was a
great work of art. During Uzumé's performances
on the drum-like box, she blew a bamboo tube
with holes pierced in it. The other deities kept
time by clapping together pieces of hard wood,
thus making music in orchestra. Another deity
took six archers' bows, and, laying them together,
strung them with cords made of hanging moss,
and so the *koto*, or Japanese harp or piano, was
invented. Fifes, drums, cymbals, and harps were
thus used together, besides the tinkling bells
which Uzumé held in her hand. As Uzumé
danced she sang a stanza, and thus music and
poetry, and probably numbers or mathematics,
were born together. The verses which she sang
may be translated either, —

> "Gods behold the cavern door,
> Majesty appears, — hurrah!
> Our hearts are quite satisfied,
> Behold my charms!"

or, —

> " One, two, three, four,
> Five, six, seven,
> Eight, nine, ten,
> Hundred, thousand, myriad."

Any one who travels through Japan, in places where the old fashions and customs are still kept up, will see many souvenirs of the Uzumé comedy. Pretty girls still peep into the round or star-shaped mirror to see their lovely faces and to heighten their charms.

See the working-maid, short and plump. She has little black oblique eyes, puffy red cheeks well dimpled, and raven-black hair, with a strand or two loose at the side, and well parted in the middle. See her about to wrestle with broom or scrub-brush, or to plunge down and hoist up the well-bucket slopping over with water. First she will tie up her long, loose sleeves as Uzumé did, and when she laughs, which is often, it will be with a crackle. She is an Uzumé all over again.

Wait to see a lovely girl, with refined face and willowy figure, arrayed in all the glory of colors blended with exquisite taste. Enter her home, perhaps, on New Year's Day. I remember one such, the daughter of a Cabinet minister, a princess in beauty and character, and nearly so in rank. All glorious within and lovely without, she was withal full of sparkle and color. Who

blames her for inquiry at the mirror? A feast to the eyes, she is the Sun Goddess all over again.

When one goes out on festival days, and sees before the temples, or in *matsuri* processions, the merry-makers with curious head-dress, with shrill flute, drum, dancing, and tricks funny and fantastic that keep the crowd in a roar, he knows that they are performing the divine comedy again. Or the *kagura* — "the capers which make the gods laugh" — are cut by men with "the lion of Corea" over their heads and concealing their legs. Corea is the country from which many of the gods, perhaps the Sun Goddess herself, came, and to which Susanoö, the Moon God, was banished.

Stuck in the shining black tresses of the maidens will be seen the tinsel hairpins, of wonderful size and glitter, just as the gods first fashioned them. The festoons of twisted rice-straw, which will be found strung over gateways and around offerings in house and temple, tell of the ropes thrown behind the Sun Goddess which kept her from reëntering the cave. The bamboo branches tied with white or gay-colored strips of paper point to the jewel-hung trees which charmed the lady peeping out of the cave. The *sakaki*-trees borne at funerals or on gala occasions, the wands with notched strips of white paper, and indeed almost everything in their mythology, may be seen in use to-day, or, if no

longer in fashion, they may be found in the
museums where they have come to resurrection.
The curved jewels, the copper bells, the strange-
shaped swords, and relics of by-gone ages, have
been found in the tombs, or dug up out of the
ground from under the mould of a thousand
years, in the place where old imperial capitals
once were.

Early Japanese civilization was not Chinese,
but distinct and original. The arts began early,
and poets and myth-makers probably lived at the
same time with the inventors. They knew how
to tell of famous events, and of useful or beautiful
inventions, in attractive language and in poetic
phrase. There were poets in those early days.

There are some foreign scholars who think the
Japanese mind prosaic, and its literature destitute
of genius, but this is an extreme opinion. In
Japanese mythology are many wonderful and
beautiful stories which show deep poetic feeling
and rich imagination, while they are, withal, of
real originality.

It would take a long time and many books to
recite all the fairy tales, and the lovely or horrible
stories, in the Kojiki, or Book of Ancient Things,
and to give the local legends which tell poetically
the origins of ornamental and useful things and
of trades and occupations. The carpenters, black-
smiths, jewelers, potters, dyers, weavers, and other
workers in the arts have severally their patron

gods and saints. Thus, through mythology, which is but decorated or gilded history, there is a sunny side to toil. To the Japanese child, all things began in Japan, which is the Holy Country and the Land of the Gods. To the foreigner, who hangs on his walls a costly Japanese picture upside down, or prints an Oriental map, a coin, or diagram likewise, things Japanese are only puzzles or barbarous curiosities. To read aright the meaning of Japanese fairyworld is to hold a key to an enchanted palace of beauty.

CHAPTER VI.

THE CONQUEST OF THE EAST.

IN the eyes of critical students, Japanese history, so called, is not worth much until after the fourth century. All the stories before that time are so mixed with the stuff of which fairy tales are made, that they cannot be accepted as fact. Instead of taking as real what Japanese writers of history say about the early ages of the empire, we prefer to interpret the ancient writings for ourselves. By studying the oldest poetry, relics, and legends, we obtain from them a true picture of the life and times of the Japanese before Chinese civilization and Buddhism came in to change them. Imbedded in many of the old legends is, no doubt, much interesting material for history.

Even yet, in Japan, the Mikado is popularly believed to be divine or semi-divine. Hence it is not yet safe for a native of the Divine Country to write about the emperor's ancestors as if they were men. To the foreigner, the early ages are as the ages of fairyland, where clocks, seasons, sunrise and sunsets are unknown.

To the country folks in Japan, these ages were

divine, and the wonderful *kami* or gods lived in them. They were more glorious than the present degenerate times, when only common men are the emperor's advisers. Even as late as the year 1892, a learned professor in the Imperial Univer sity was punished for studying Japanese history with critical care, as Europeans study it, and say‧ ing that the Mikado's ancestors were Coreans.

When the government says that Jimmu Tenno, the first Mikado, "ascended the throne" B. C. 660, or 2,552 years ago, every Japanese is ex- pected to believe it, at least to believe it in the Japanese language. If he doubts it, he must doubt it in English, or German, or French. To doubt, and write one's doubts in Japanese, usually means punishment in some way, and in old times it meant imprisonment. The common people must not find out the truth too suddenly, for the mys- tery-play of the divinity of the Mikado is not yet over. Even Japanese educated in European uni- versities must still talk as if the events which are said to have occurred a thousand years before time was recorded in Japan were known in de- tail.

The Kojiki, or Record of Ancient Things, written in A. D. 712, but not printed until 1642, is a sort of Japanese Bible. The Nihongi, or Narratives of Japan, was written in A. D. 720. It is to the Kojiki what the books of Chronicles are to the books of the Kings. It tells us quite

fully about the seven long-lived emperors, five of
whom died when over a hundred years old, and
one of whom reigned for a century and a year.

Many of the stories told of the *kami* or deities
are very curious. In one case a prince marries a
beautiful princess. The maiden's name, Hinaga,
means fat and long. She changed into a serpent,
from which the prince fled. Many of the gods
had tails, and some of them had horns. The scene
of the narratives is first in Idzumo, then in Ya-
mato, and then in other provinces. The object
of the stories and narrations seems to be to ex-
plain the origin and note the ancestry of the
tribes. As matter of fact, these ancestors are
now the gods worshiped at the local shrines all
over Japan. In nearly every town, village, and
neighborhood, in addition to the Buddhist divini-
ties, the people still worship local gods. These
gods were once nothing more than the savage
ancestors of the men who still hoe the mud of the
rice-fields, and kindle smudge-fires to smoke out
the mosquitoes. According to the old chronicles,
it was about the beginning of the Christian era
that the first rudiments of civilization began to
appear.

Two of the emperors, Sujin and Suinin, were
great civilizers, the former reigning from 97 to
30 B. C., and the latter from 29 B. C. to 70 A. D.
By them, much of the land was definitely laid out
in rice-fields, and taxes were levied. Pestilence

was averted by making gifts of spears, shields, and cloth to all the gods of the rivers and hills. To this day, the Japanese people hang up strips of cotton and hemp cloth in the form of handker- chiefs at the shrines of the gods and on sacred trees. The offerings made, when fresh and bright and gayly dyed in colors, are very pretty. They hang until bleached and frayed by sun, wind, and rain. When blown away, or shredded to rags, they make a most disreputable-looking sight. In our days, having learned how to make paper from rags, and knowing the value of the material, they send the old offerings to America, or turn them into newspaper or book stock in their own new mills.

After the pestilences had been appeased, a war with a rebel chief fought, and other adventures undergone, the emperor Suinin sent a man named Tajima-mori "to the Eternal Land to fetch the fruit of the everlasting fragrant tree." This means probably that he went to the warm Riu Kiu islands, and "the fruit of the everlasting fragrant tree" is what is now called the orange. From the name of one of the many species, Tachi-bana, came the name of a Japanese noble family which is almost as famous in the history of Japan as that of Orange is in the history of England.

One of the figures that belong to the early heroic ages is that of Yamato Daké no Mikoto, who was a son of the twelfth Mikado. He is

believed to have conquered all eastern Japan for
his father's empire. When a young man, being
very beautiful of face and figure, he borrowed his
aunt's clothes, and disguised himself as a girl.
Concealing a sword in his bosom, he secured
entrance to the tent of a rebel chief whom he was
fighting in Kiushiu. Once inside the cave where
a banquet was to be held, instead of a yielding
girl like Judith in the pavilion of Holofernes, the
rebel found an athletic youth who overwhelmed
and killed him. This feat the Japanese artists
love to picture very often. After this exploit he
was called Yamato Daké no Mikoto, or, His
Augustness the Bravest of Warriors.

Of course, when the tribes which the Yamato
or Mikado's clan were trying to subdue would
not submit, or when they became hostile, they
were called "rebels," and the Yamato clan-chief
or Mikado usually marched in person to chastise
them. In this case, the Mikado, who must have
been, according to the Kojiki, one hundred and
twenty-three years old, sent his son, Yamato Daké
no Mikoto.

The handsome Warrior Prince set out with his
army from central Japan, and first visited Isé,
where still is the holy shrine of the Sun Goddess.
Here were kept the imperial regalia, or three
precious emblems, sword, mirror, and crystal ball,
which Ninigi had brought down from heaven.
He left his own sword under a pine-tree, and the

priestess, his aunt, gave him one of divine temper. In all Japanese history, the sword is almost a holy thing as if alive; it is the emblem of the soul of the hero or brave warrior who loyally serves the Mikado. All famous swords have names. Many of them have dates and mottoes, or verses of poetry, engraved on them. Those forged in the ancient times were long, perfectly straight, and double-edged.

The sword given to the Warrior Prince was that taken out of the tail of the eight-headed dragon slain by Susanoö, who had intoxicated the monster with eight tubs of saké, or rice-liquor. It was called "Cloud Cluster," because born amid the clustering clouds of heaven. The priestess also gave her nephew a bag which she told him to open in time of trouble. In later times, swords, when first given to boys to wear, had a charm-case fastened to them. Marching eastward, he met the enemy on one of the grassy plains near the base of Fuji Yama. When these eastern or Ainu savages saw the army, they surrounded it and set the brushwood on fire. For a moment it seemed as if the Yamato men would be swallowed up in the flames. In this emergency he bethought himself of the bag which his aunt had given him. Opening it, he found materials for striking a fire. So, first mowing away the grass and underbrush with his sword, he struck a fresh fire and kindled such a flame that his enemies were driven away.

He now changed the name of his sword to "Grass-
mower." He then easily conquered the enemy
and subdued the land.

Crossing the Hakoné mountains he descended
into the great plain of Yedo, and took possession
of the whole region round Yedo Bay. The
country thus brought under the Mikado's rule
was called Adzuma, a word which means "my
wife." When Yamato Daké was crossing a cer-
tain bay or river, in what is now the province of
Musashi, the god of the water raised a tempest.
Seeing this, and with the purpose of saving her
husband, the princess Tachibana, wife of the
hero, leaped into the waves to appease the wrath
of the gods. By drowning herself she saved her
noble husband. Seven days afterward, her comb
floated ashore, and her husband placed it in
a tomb as a precious relic. In recrossing the
mountains, on his homeward march and by way
of a more northerly road, he looked back towards
the scene of his wife's sacrifice on his behalf.
He sighed three times, saying, "Adzuma, ha ya,"
or, "Oh, my wife!" The Japanese use this name,
in poetry, for all eastern Japan ; and when they
bought an ironclad ship from the government of
the United States, they changed its name from
Stonewall to Adzuma.

Yamato Daké met with many adventures with
the gods of the strange countries through which
he passed, but he overcame them as he went.

One of the *kami* appeared to him as a white deer. Another lighted smudge-fires to drive away the mosquitoes. Another became a white boar that filled all the region with mist and hail. Another opposed him in the form of a serpent. He overcame or circumvented them all, and finally reached home after an absence of three years. Weary and exhausted after his long campaign, he composed some poetry, and while singing part of a stanza died. His body turned into a great white bird, and flew away towards heaven.

Yamato Daké is one of the great figures that loom up in the legendary history of early Japan. Around him many wonderful stories cluster. With the artists and novel-writers, myth and fairy-tale makers, nurses and grandmothers, boys and girls, he is a great favorite. Many of the curious customs of the Japanese, such as hanging up garlic before gates and doors in time of contagious sickness, and the wearing of amulet-bags in the children's belts, cannot be easily, or at least plainly, understood without remembering him and the stories told about him. He is believed also to have been the inventor of the Japanese *uta*, or poem, which always consists of thirty-one syllables. It is arranged in five lines, the metre being 7, 5, 7, 5, 7, or "three 7s and two 5s," as the hymn-books would say. To make this exact number of thirty-one syllables, dummy words which have no sense or meaning, but serve

only for sound or bulk, are often used. These are called head or pillow words.

Thus in 1854, when Commodore Perry anchored his ships in the Bay of Yedo, in the province of Musashi, near the place where Yamato Daké's wife threw herself in the sea, a Japanese poet wrote a stanza of five lines which we translate in four, as follows: —

> "On Musashi's bright sea,
> The rising moon
> In California
> Makes setting gloom."

In the Japanese original, the five-syllable word, forming the whole of one line, is only a bolster or pillow word for the stanza to rest its head upon, and meaning nothing whatever. In the Japanese *uta*, or poem, only pure Japanese words are allowed. In the longer poems, and other forms of composition, Chinese terms are freely employed.

It is also thought that Yamato Daké first taught the making of fire by flint and steel. At the time of Uzumé's dancing before the cave of the Sun Goddess, the bonfires were lighted by a blaze obtained from a fire-drill, such as savage men still use in many parts of the world. Yamato Daké kindled the grass by means of flint and steel given him in the bag furnished by his aunt. So here is probably the story of a new invention which was very wonderful in its time.

Heretofore "the Empire of Japan," which

later historians write about, meant, in reality, only Yamato, or Idzumo, or a comparatively small region in central Hondo. After Yamato Daké's time, the territory of the Mikados was much more extensive, being ruled more or less successfully by them. The Yamato tribe extended their power to about the thirty-seventh or thirty-eighth parallel of latitude. This line would include the part of Japan now most thickly populated. Nevertheless, the eastern tribes often broke out into rebellion, and many military expeditions were necessary to tranquilize the various disquieted regions. The successful general was called Séi-i Tai Shogun, that is, the Pacifier, or Queller, of the Barbarians. The title, first granted in A. D. 813, was to one Watamaro. This Shogun, from being a general in the army, afterwards became the great Tycoon, whom our fathers supposed to be an " emperor "!

CHAPTER VII.

COREA AND BUDDHISM.

THE Japanese books have much to tell about a famous lady who, they say, lived in the third century. The artists often picture her in the robes of a princess. She was a wonderfully clever woman, who was probably much more enterprising than her husband. Indeed, the Japanese say she conquered Corea. This is the way the event came about: —

Jingu was the *kōgō* or wife of the fourteenth Mikado, named Chiuai. To this day, the Empress of Japan is called Kōgō sama. In a battle with rebels he was killed, and she was left a widow. It is said that she lived to be one hundred years old, and ruled the country from A. D. 201 to 269. Her counselor was the Japanese Methuselah, Takénouchi, who lived to be several hundred years old. When she planned to conquer Corea, all the *kami* helped her, one bringing timber, another iron, another cordage for her fleet.

Assembling her ships and soldiers, Kai Riu Ō, or the Dragon King of the World Under the Sea, presented her with two flashing balls of crystal. These jewels controlled the tides, making ebb or flood as desired.

Once fairly out to sea, a great storm came on, and then Kai Riu Ō, or the Dragon King, sent huge fishes to push and pull the vessels forward. When the Coreans lined the shore to oppose her invasion, she threw in the ebb-tide jewel, which caused the sea to recede and leave the ground bare. When the Coreans rushed forward to attack the Japanese ships, which, as they supposed, were stranded, the queen threw in the flood-tide jewel, and the Coreans were drowned in the in-rushing waters.

Safely landing her army on the coast, the country was easily conquered. The king was reduced to submission, and sent eighty tribute vessels loaded with gold, silver, pictures, silk, and precious things of all sorts, with Corean lords and ladies as hostages. Many skilled workmen and experts in fine arts were also taken home with them by the Japanese.

On reaching Japan a son was born to the empress, and named Ojin. The baby boy had a mark under his arms like a quiver. He became a great warrior, and after his death was worshiped as the God of War. He is the Japanese Mars. This was their first foreign war; and on account of Jingu's conquest, the Japanese, even down to 1873, claimed that Corea belonged to Japan. Unfortunately, however, Corean history, as thus far studied, knows nothing of this legendary exploit.

If we examine Japanese fans, vases, or carvings, we shall be pretty sure to find either Queen Jingu, or Ojin, her baby, the young God of War, or the Dragon King and the tide jewels, or Takénouchi, the prime minister, who usually holds Ojin in his arms.

What is the nucleus of the story?

Though the fact be doubtful, the story entered very fully into the art and lore of this warlike people. The people of Kiushiu built a temple in honor of Queen Jingu's son, and it is said that eight white banners fell down from heaven upon it. We shall see how, long afterwards, when the Buddhists baptized the old native gods with new names, the boy baby, Ojin, became the great Hachiman, or the Great Buddha of the Eight Banners. Every Japanese soldier in the Middle Ages used to invoke the aid of Hachiman, and many of them yet do so. They also carry his image as an amulet in their caps. The precedent of Jingu's conquest, A. D. 203, was one chief cause of the great Japanese invasion and occupation of Corea in 1592–1597. It also brought on a civil war in Japan in 1874. The question of considering Jingu as one of the Mikados, or empresses in the line of the one hundred and twenty-two or more, has often been the occasion of hot disputes and political quarrels. Most native historians now omit her name as empress.

Exactly how much is true in the early traditions

of the Japanese, which were first written down in the eighth century, it is difficult to say. It seems quite certain that many of the so-called gods and goddesses in the Kojiki were nothing more or less than Coreans who came over into the Sunrise Kingdom. Even the Sun Goddess herself was probably only a Tartar or Corean lady, or queen of a tribe. The same may be said of Susanoö, the god-man in the moon, and the Oshiko Mimi no Mikoto, whom the Japanese especially celebrate.

It is possible that in the native mythology we find imbedded the fantastic account of what we may call the first of four great waves of civilizing influences which Japan received from the West, in the third, the sixth, the sixteenth, and the nineteenth centuries. Queen Jingu's invasion of Corea was but an episode in a long series of influences upon Japan from the Continent. From the mythical times until the tenth century, there came to the Sunrise Kingdom a steady stream of emigrants. Many of these were soldiers, farmers, skilled mechanics, physicians, missionaries, artists, and teachers of the arts and sciences. They brought tools, trades, books, scriptures, idols, costumes, medicines, and almanacs. In a word, they were men who introduced new principles of civilization. They so improved the Japanese people that they are now gratefully venerated or worshiped, and called heroes, saints, gods, and demigods.

Concerning the third and fourth centuries, there is little said in the native histories, except that silkworms were introduced, and some improvements made in rice-culture. Civil wars at home and fights in Corea were common. Most critical scholars think that it is not until the middle of the fifth century that dates in Japanese history can be relied upon.

In the reign of the twenty-sixth Mikado, the first Buddhist images were brought to Japan. It was not, however, until the year 552 that Buddhism was regularly introduced and the Japanese gained a new religion. The king of one of the three kingdoms in Corea sent over priests, scriptures, idols, and everything necessary to furnish a temple. The bonzes, or missionaries, preached the new doctrines at court, but met with violent opposition from the Shintoists, or worshipers of the *kami*. The Mikado, therefore, declined to become a Buddhist, but gave the books and images to one of his high officers, Soga no Inamé, who honored Buddha.

This nobleman at once installed the priests and idols in his house, which became the first Buddhist temple in Japan.

Like most religious devotees all over the world, the conservative Shintoists ascribed the diseases which presently broke out to the wrath of the native gods, who had sent the pestilence upon the Japanese to punish them for harboring new

deities. The Shintoists burnt down Soga no Inamé's house, and hurled the image of Buddha into the river. In turn, such awful calamities visited the people that the temple was allowed to be rebuilt, for this time the Buddhist powers were angry.

Fresh missionaries came over from Corea, and priests and nuns went about preaching and gathering converts. In the time of the female Mikado, Suiko (593–628), the followers of Buddha numbered many thousands, and the empress openly declared herself among them. Her adopted heir, Shotoku, also zealously assisted her, and at his death there were forty-six Buddhist temples, eight hundred and sixteen priests, and over five hundred monks and nuns in the country. The Buddhists greatly venerate the name of Shotoku, whose posthumous title means Great Master of the Illustrious Teaching of Virtue.

It is not possible here to explain what the religion of Buddhism is. We can only contrast it with Shinto. The latter could hardly be called a religion, because it had then no writings and no priesthood. Its shrines were very simple, without images or ornaments, and as bare and barn-like as most early Protestant meeting-houses. On the contrary, Buddhism is, in outward form, as rich and bright, and attractive to the senses, as Roman or Greek Catholic churches. Besides images, pictures, lights, altars, rich vestments, masses, beads,

wayside shrines, monasteries, monks, nuns, shorn priests, bishops, archbishops, pope or lama, saintly intercession, indulgences, miracle-working relics, exclusive burial-ground, and splendid sacred edifices for worship, Buddhism has scriptures, rules of discipline, doctrines, a calendar of saints, and nearly everything visible that is found in the Roman system.

Like all other religions, Buddhism has been propagated by missionaries and teachers with patience, earnest prayers, plenty of money, and hard work. We have not space to tell the story of the planting of the faith, its missionary and its doctrinal development, nor of its great teachers, saints, and heroes. It is enough to say that it required nearly a thousand years to convert the whole Japanese nation. When, in the ninth century, the learned priest Kobo taught that Shinto was but another form of Buddhism, and that even the *kami* or gods were early manifestations of Buddha or his saints, and so baptized all the old deities and festivals with new names, the triumph of the faith was secured. Henceforth Buddhism became the chief religion, though Shinto was never wholly forgotten. The old doctrines and practices were kept alive by the scholars and devoted patriots until the great revival and ascendency in our own time. To the mass of the people, Shinto was but a system of national legends. They knew that a Buddhist

temple was a *tera*, and a Shinto shrine was a *miyu*,
but they could not go much further.

What Buddhism has been to Japan, and done
for her people, let Professor Basil Hall Cham-
berlain tell. We quote from the invaluable little
book, " Things Japanese : —"

" All education was for centuries in Buddhist
hands. Buddhism introduced art, introduced med-
icine, moulded the folk-lore of the country, created
its dramatic poetry, deeply influenced politics and
every sphere of social and intellectual activity. In
a word, Buddhism was the teacher under whose
instruction the Japanese nation grew up."

CHAPTER VIII.

HOW THEY LOOK AT THE WORLD.

THE dreams of a Japanese child, the thoughts of his mind, the action of his brain, are different from those of children born between Boston and San Francisco. His eyes see more, and less, than ours when looking out on the world. The stars, the trees and flowers, the sea and land, have each a different story to tell. From his babyhood, the fairy tales, the explanation of things, the answer of nurse and parents and grandmother to his Why? and How? are not what the answers to us have been. Hence his dreams and thoughts are quite different from those of our boys and girls.

In these days, of course, at the public schools, the Japanese boy learns the geography of the world and the history of nations, besides getting a smattering of various sciences. Then he comes home to bother his father and mother with strange words and notions. Yet, with the great multitude of the people, especially those in the country, the old opinions still prevail, and will hold their own for centuries to come. For example, earthquakes are very frequent and often dangerous in Japan.

In October, 1891, about ten thousand people were killed or wounded by them. Naturally, one asks what causes them. A scientific man, in trying to explain them, will talk about the "attraction of gravitation," "density," "pressure," etc., etc.; but to the Japanese farm-laborer the cause is plain enough. It is the *jishin-uwo*.

Now the earthquake-fish is a great monster somewhat like a catfish. It is seven hundred miles long, and holds the world on its back. Just as the Greek children were told that under the volcano of Stromboli, in the Mediterranean, was buried a giant, and that his writhings caused the earthquake, so the Japanese countryfolk think that the wrathful wriggling of the great catfish makes houses fall and the ground crack. With his tail up in the north, and his head in the region of Kioto, he can shake all Japan. What hinders him from utterly destroying the country?

When the world was first created by Izanagi and Izanami, there were two gods who were charged with subduing the northeastern part of Japan. Having quieted all the enemies of the Sun Goddess, one of them, Kashima, stuck his sword in the earth and ran it through to the other side, leaving only the hilt above ground. In the course of centuries, this mighty sword shrunk and turned to stone, and the people gave it the name of Kanamé-ishi. It is the rivet-rock of the world, binding the earth together, as the *kanamé* or rivet binds

the sticks of a fan. No one can lift this rock except Kashima, who first put it there. Yet even he never touches it except when the earthquake-fish gets very violent. Then the god holds him down with the rivet-rock and he becomes quiet.

For the causes of other things, these people, who lived so long out on an island separate from the rest of humanity, and thought " the world " meant Japan, were accustomed to look to their mythology, just as the old Greek children did to theirs. For example, when the Japanese scholars learned from the Dutchmen who lived at Nagasaki that the earth revolved daily on its axis, spinning round like a top in motion, they at once remembered that Izanagi had thrust in his spear and stirred the earth around. This, then, they thought, was the cause of the daily revolution of the earth.

The spot where Izanagi came down to earth, and stuck his spear in the ground to make it the main pillar of a palace, was formerly the North Pole; but since that ancient time the earth has wabbled over. The spot marked by Izanagi's spear is at Ésbima, an island off the eastern coast of Japan. This proves, they think, that Japan lies on the summit of the globe.

Foreign countries, as well as several thousand small islands of Japan, were not made by Izanagi, but were formed by the foam and floating mud of the seas curdling and becoming solid.

In Japanese poetry and romance, there are many honorable names for the sun and moon. In pictures and poems, much is made of these two luminaries, but very little of the stars. The poets, lovers, and romantic folk spend many hours in gazing at the moon. On moonlight nights, in mild weather, thousands of people throng the bridges, walk the streets, or lounge in boats on the river, enjoying themselves in looking skyward. The houses have moon-viewing chambers. The novels are full of the same sentimental habit. The Genji Monogatari, or story of Genji, is one of the most famous in Japan. It is often quoted in speech and book, and its scenes and characters are illustrated on fans, napkins, and literature almost as much as those of Shakespeare are with us. It has fifty-four chapters, named after the beautiful women beloved of Prince Genji, and each woman's name is that of a flower. It was composed in the year 1004, by its authoress, under inspiration of the moon reflected in the water of Lake Biwa. She wrote two chapters the first night, and finished the whole work in a few weeks. The moon filled her soul with blossoming thoughts and images.

Yet, as I have intimated, while a large book on the lunar enjoyment of Japanese people could be easily compiled, the stars are quite neglected both by poets and people. Probably this is because the planets and stars were made from the

mud which flew off from the earth when stirred
up by Izanagi. Some wise men used to think that
the stars were made chiefly to guide navigators
and other foreign people to the land of the Mi-
kado to bring their tribute to him. In fact, some
old-time Japanese were as conceited as the Chi-
nese whom they ridicule.

Occasionally a girl is named Hoshi, or star, but
the people have, in the name, hardly any special
poetical associations. Quartz crystals are sup-
posed to have dropped from the stars, or from a
dragon's mouth. The one story connected with
the stars is of the herdsman and weaving-girl.
These are the stars in Aquila and the star Vega,
on opposite sides of the Milky Way. Japanese
children celebrate with great glee the festival of
the Weaving Princess and the Ox-King on the
evening of the seventh day of July. During
the day they tie bright-colored strips of paper,
written over with poems, to bamboo poles, set these
up in various places, and hope for good luck. The
lovers up in the sky can only cross the River of
Heaven, as the Milky Way is called, on this one
night. Then, if the weather is fair, and the river
not overflowed, myriads of magpies fly together
and make a bridge over the stars for the pair to
cross and meet.

Up in the moon grows a *katsura*, or cassia-tree,
whose leaves in autumn turn red. This is what
causes the brilliant color which so delights the

moon-gazers. In August and September, both
young folks and middle-aged will sit up all night
until well into the morning to see the moon rise
over the sea, meanwhile drinking rice-wine and
composing poetry. Every one who has studied
the pictures on fans and cabinets is familiar with
the bright red moon of the Japanese artists.
Usually it is seen rising behind bamboo groves.

In the three great nights in the lunar year, the
harvest moon, which the Japanese call the bean
moon, is most looked at; then the people make
offerings of beans and dumplings, and decorate
their houses with eulalia grass and Japan clover,
which botanists name Lespedeza, after Lespedez,
an old Spanish governor of Florida. The next
following moon, in September or October, is the
chestnut moon, because celebrated with bouquets,
chestnuts, and dumplings.

Until 1872, as in all old nations, the moon
marked the month, and the lunar calendar was
the rule. In that year, greatly to the disgust of
the Chinese, the Japanese left off the old fashion,
and counted their days, months, and years accord-
ing to European almanacs. At first the change
wrought sad havoc with the old customs. The
anniversaries, which always came on such a day
of such a moon, had to be adjusted to the new
state of things. Now, however, all but the priests
and a few old folks are used to the change, and
like being in step with the rest of the world.

In the moon, the poets and novelists not only locate a great city, whose exact site is as uncertain as that of Norumbega, but also tell of a moon-maiden who comes down to the earth. She is very lovely, sometimes has wings, and is shining bright like crystal. She is sent to the earth as a punishment for her offenses. In one story, an old bamboo-cutter finds, in a joint of a growing bamboo cane, a tiny human child no longer than a lady's finger. She glistens with light like a gem, and grows to be so amazingly beautiful that all the princes fall in love with her. She is called Princess Splendor. Like the imperious lady of other fairy worlds, she lays impossible tasks upon them. One lover is told to go to India and bring back the stone bowl of Buddha; another must get the jewel-lance from Horai in the Eternal Land; a third must snatch the jewel from the claws of the dragons under the sea; and so on through a long chapter. Even the Mikado falls in love with her; but notwithstanding that he sets two thousand expert archers about the bamboo-cutter's hut and on the roof, she is carried away in a flying chariot to the moon, leaving the old man broken-hearted.

In another case a moon-maiden, who has taken off her wings and suit of feathers to bathe in the sea of Suruga's shore, has her celestial clothing stolen by a fisherman. Only after much trouble does she regain her fairy suit, and then she flies away to the moon. A shrine was afterwards built

to mark the spot, and the story is still told to the children and danced and acted to their elders.

The common people, who are more prosaic in their notions, and depend more on Chinese and Buddhist stories, see, instead of a man in the moon, a hare pounding *mochi*, or rice-dough for cakes. In the Hindoo story, the hare pounds drugs as a punishment; but as in Japan the word *mochi* means both " full moon " and " rice-pastry," the Japanese will have it that the pestle of " the pearly hare " is beating, in the well-known wooden mortar seen in every rice-shop, the material for the national cake. In the sun they do not see spots, but a three-legged crow. " The golden crow and the jeweled hare " are the poetical terms for the great lights that rule the day and night.

In Japan there is a kind of opera, or panto-mimic dances, called *no*. Foreigners soon tire in seeing even one performance of these dances, for they often last many hours. They consist chiefly of music and pantomime, with strange gestures, motions and grimaces of men curiously dressed, often with grotesque masks, and perhaps with trails several yards long. To the foreign spec-tator they are wearisome, mainly because he does not understand or appreciate them. He sees only motions which have no meaning to him. The Japanese delight in them because they represent to him the events and scenes, tragic, dramatic, or comic, of his fairy world.

For example, if a man is making curious motions, as if trying to escape a flood, and dodging his head, with his mouth up in the air as if to escape drowning, while another holds in his hand two shining crystal balls, he knows the dance represents the story of Princes Fire Fade and Fire Glow.

If one man be dressed in a dragon-helmet with a back-cover of glistening scales, behaving like a drunken man, while another is brandishing a great sword, he knows it is the story of the Moon God who slew the eight-headed dragon after intoxicating him with rice-wine. Similarly, also, the archer who slew the dragon-centipede, and delivered the maiden doomed to death; or the moon-fairy tantalized by the fisherman who is keeping her suit of feathers; or the fox-god that helped the famous sword-maker Munéchika to forge his blades, — are represented in the *no* dances. The musicians and singers forming the chorus tell the story and the dancers act it out. The music represents the gentle rain; the wind stirring the pine-trees; the pheasants calling to their young; the nightingale's notes, or the crash of thunder, the lapsing of waves and the roar of the sea.

In a word, the Japanese cultivate their flowers, teach their children, write their books, name their minerals, animals, shells, and living pets, write their stories, paint their pictures, look out upon

he universe, and populate the heavens, the air,
he earth, and the waters, differently from us, be-
ause their ancients, their scriptures, their country,
und their insular experiences are unique.

CHAPTER IX.

THE MIKADO AND HIS SAMURAI.

FROM the fifth century the Japanese stand in the clear light of history. With writing, and methods of reckoning time, it is easy to keep records of what actually happened. We find that after the seventeenth Mikado, Nintoku, dies, at the age of one hundred and ten years, there are no more long-lived emperors. Even on the throne, and called Sons of Heaven, they die at about the same age as common folks. After clocks and almanacs come into use, it is found that only three emperors in the whole of the long line have lived to the age of fourscore years, and but a few to the age of seventy. From the death of Nintoku to Kimméi, in whose reign large companies of Corean scholars, teachers, missionaries, and cunning workmen came over to Japan, the average reign of fourteen Mikados was but ten years.

Buddhism wrought a great change in both the court and the nation. Shrines, temples, and pagodas were built all over the country, and art and trades were greatly stimulated. Painters, carvers, and shrine-makers multiplied. Education, though not yet national, grew to be more general. Books

became less rare; manners and customs were im-
proved. The priests were often real civilizers,
making roads, sinking wells, maintaining schools,
and softening manners. One of them introduced
stick-ink and ink-stones, and the use of millstones
for grinding.

The most striking effect of the new faith was
seen in the court. It wrought radical political
effects, for in time it came to pass that many of
the Mikados, who had become zealous Buddhists,
left the throne and retired to cloisters, while the
empresses became nuns. Abdicating their author-
ity, they nominated their sons to the throne. It
frequently happened that the heir was a mere
child. This gave the ambitious priests and nobles
at the court the opportunities they wanted for
carrying out their own schemes, as we shall see.

Besides the great change in religion, art, lite-
rature, and politics wrought by Buddhism, the
form of government was modified by borrowing
the system then in vogue in the Chinese empire.
Japan has always been mightily affected by China,
and has borrowed much from her great neighbor,
though usually by way of Corea. The famous
Tang dynasty of emperors, one of the longest
and most brilliant in the annals of China, began
its course in A. D. 618, lasting until the year 905.
This period included the invention of printing by
blocks, the founding of the Chinese Imperial
Library and Academy, and the golden age of

Chinese literature. The laws were reduced to
codes, the official orders reformed, and the form
of government more centralized. Military con-
quests greatly extended the frontiers of China.
Commerce with the Arabs was begun, the mari-
ner's compass put to use in sea voyages, and
porcelain and far-oriental products became well
known among them. At the Chinese imperial
court at Singan, embassies from Rome, Nipal,
Persia, Thibet, Corea, and Japan had audience of
the emperor.

The Japanese have always been great bor-
rowers, thus showing their intelligence and ap-
preciation of what is good. Furthermore, they
usually improve upon what they borrow. As they
see, in the nineteenth century, the superiority of
the civilization of Christendom to their own, so, a
thousand or more years ago, they perceived that
the Chinese methods were better than their own.
Laudably they determined to be second to none,
and so they began a system of reforms which
introduced a political, even as Buddhism set in
motion a religious, revolution.

In the most ancient times, the method of gov-
ernment was that of feudalism. That is, all the
land belonged in theory to the Mikado, by whom
it was feud or let to lords or tenants on condition
of service. When the ground was cultivated,
each farm was divided into nine parts, eight
being for the local lord who owned or employed

the serfs or laborers who tilled the soil, and the ninth part being cultivated for the Mikado. The tribute rice or other products were brought to the imperial treasury laden on horses gayly decked with crimson trappings and tinkling bells, and the occasion was usually a scene of festivity.

This old, simple feudalism was in the seventh century abolished (just as the vastly more complex feudalism was swept away in 1871), and a new governmental system, in which everything centred in the capital, came into vogue. New orders of nobility were created. In the nine ranks there were, in all, thirty grades. Eight boards or departments of government were created, forming the Imperial Cabinet. These were supervised by four high ministers, who also had oversight of the governors who were sent out from the *kio* or capital to rule the provinces, collect the taxes, keep order, punish the violent, and execute the laws. Each noble or officer had a rank which was separate from his office. At court, where etiquette was of as much importance as religion, all questions were settled according to precedence in rank.

In most old countries the two dominant castes are those of the priest and soldier. In Chinese Asia, the priest, as such, has not relatively the office and rank held in Western Asia and Europe. The two great classes are the civil and the military.

The civil officers served at the capital or in the provinces. The military classes formed the army, the militia, and the reserve. The soldiers of the first class were on garrison duty, the second were called out when rebellions had to be put down, but only rarely were all the able-bodied men under arms. At first the business of soldier and farmer was carried on by the same man, the spear or the hoe being taken up as occasion required. In course of time, however, it was found best to separate the men into two distinct classes. The strong and hardy, especially if they had money and horses and were good archers, became professional soldiers. The poorer and weaker men were left to till the soil and remain farmers. Thus, the farmer and the fighter were made distinct from each other, and the military class became the first of all among the people. Other classes later grew up until they numbered four, — soldier, farmer, mechanic, trader; and these were subdivided into eight, but the soldier was the first of all.

This division took place a thousand years ago, but it was one of the most momentous in the history of the empire. The farmer stayed where he was, to dig, plant, toil, and pay taxes. At first only the guards in Kioto, whose business it was to *samurau* or serve the Mikado and protect the palace, were called Samurai; but gradually the name was taken by the whole military class, who

from this time forth entered upon a career of development. War, adventure, the cultivation of manners, refinement, and afterwards of learning, literature, and political skill, have made the Samurai the typical progressive Japanese. In our day there are three classes in Japan, — nobles, gentlemen, and common people. The Samurai are the gentlemen, now called Shizoku. From this class have come nearly all of the famous men of Japan since the Middle Ages, while in our day most of the Japanese students in America and Europe are from this class. These young men at home were usually trained in three religions, and to understand thoroughly and practice skillfully the two professions of arms and letters.

Of the three religions, one is native and two were imported. Shinto, or the Way of the Gods, is the native religion. It consists of the worship of nature and of ancestors, with many rules about cleanliness and purity, and not a few picnics and merry-makings. Confucianism, imported from China, teaches obedience and faithfulness to emperor, parents, teachers, and all superiors, and makes piety or filial reverence pretty much the same as religion. Buddhism inculcates faith and charity. It made its disciples kind to the poor and to the animals. In a word, "Shintoism furnishes the object of worship, Confucianism offers the rules of life, and Buddhism supplies the way of future salvation." The child as he grew up

had constantly before his eyes the emblems of
each of the three religions. In nearly every
Samurai's house were the moral books of Con-
fucius, the black lacquered wooden tablets in-
scribed in gold with the Buddhist names of his
ancestors, while on the god-shelf stood the idols
and symbols of Shinto. Every child and adult
had thus many things to worship ; the sun, moon,
stars, ancestors, heroes, images, emblems, animals,
waters, and hundreds of other things, visible and
invisible.

The favorite god of the school children was one
called Ten-jin, or Heavenly Man. The ambition
of every Samurai boy was to be a good penman
and scholar, and so for hundreds of years the
Japanese children have prayed to Ten-jin to help
them to master the difficult Chinese characters.
How he came to be a god, and to receive worship,
we shall proceed to tell. Most of the millions
of Shinto gods were made in like manner. The
temples in his honor are found in all the large
cities in Japan.

The Sugawara family was from ancient times
famous for the great learning of its members.
The emperor Kwammu (782–805), who took
great interest in education, and was himself
superintendent of the University, made Sugawara
Furuhito his tutor. He also granted salaries and
revenue to other Sugawara men who by learning
and literature obtained and held an honored place

at court. The school for the practice of penman-
ship and the study of the Chinese classics and
histories was founded when Kioto was first made
the capital. It was gradually enlarged and made
a university. Here flocked the young men whose
ambition was to enter the service of the govern-
ment. Here the Sugawara teachers made a great
reputation, and in their own houses gathered
large and famous libraries. Sugawara Michizané
was the most erudite of all his family. He once
wrote twenty Japanese stanzas, on twenty different
subjects, while eating his supper. He began to
write Chinese verses at the age of eleven. When
the envoy from China visited Kioto, Michizané
was appointed to receive and communicate with
him.

In a book written A. D. 893, Michizané describes
his study, in which the books were stored in three
rows of cases on four sides of his room. His
students were so well trained by him that they
usually succeeded in the competitive civil service
examinations, and were more numerously ap-
pointed to office than the pupils of other teachers.
More than one hundred of them were taught in
his study, so that the scholars usually called this
bookroom Riu-mon, or Dragon Gate. In Chinese
folk-lore the carp, by leap and ascent over the
waterfall, turns into a dragon. So the boy who
overcomes difficulties in study and passes hard
examinations wins office, rank, and fame. The

dragon is the emblem of imperial office. Michizané's works number twelve volumes of poetry and two hundred of history.

The scholar in his study was happy, but the scholar in politics had sorrow and trouble. So long as Michizané was only the tutor of the emperor Uda (888–897), or was busy in writing poetry or literature, the court politicians, thinking him only an ordinary "literary fellow," were not jealous of him. When, however, the Mikado Daigo (898–930) appointed Michizané the junior prime minister, then his enemies, the Fujiwara nobles, plotted against him. One of them, his colleague, accused him to the emperor, and secured his removal to Kiushiu under circumstances that made it seem banishment. The exiled scholar spent his time in literary labor, and made himself beloved by all the people. When he died they built a temple to his memory and worshiped him. The Mikado also repented, and bestowed on Michizané the posthumous title, Dai-jo-Dai-jin, which is the highest known to a subject. In the Shinto religion admitted as a god, he was named Tenjin. All classes from the noblest to the humblest worship him with divine honors as a typical Japanese. The twenty-fifth day in each month, in the old calendar, was a holiday in his honor, and often on these occasions an imperial messenger was sent to do obeisance at his tomb. He is, in a sense, the Confucius of Japan.

Fine manners have always been a fine art in Japan. Long before Michizané's time the arts of politeness were carefully studied at court, and among the upper classes. Indeed, it is said that as early as the seventh century there were manuals or treatises on politeness. These were studied as part of the education of the Samurai, and it may truly be said that the wonderful polish and refinement of manners among Japanese are the fruits of a thousand years of culture. Religion, ethics, education, literature, and experience in arms produced that unique specimen of a man, the Japanese Samurai. In the romance, drama, and art, which reflect actual history, the heroes and heroines are almost invariably of Samurai family. Even now, under a written constitution and a representative government, it is the four hundred thousand adult male Samurai who rule the forty millions of people, make the politics, and shape the destinies of Téi Koku Nippon, or the Land Ruled by a Divinely-descended Dynasty.

CHAPTER X.

LETTERS, WRITING, AND NAMES.

BEFORE the advent of Buddhism, with its whole train of civilizing influences, the greatest of the importations was that of writing. This brought Japan into the light of history.

The dividing line between barbarism and civilization is that of letters. A man is no longer a savage when he can write, and thus record, save up, and accumulate knowledge. Had Japan never received letters, she might still be as Formosa, and the Japanese as the Butan savages who inhabit this beautiful island.

Uncertain tradition gives the credit of the introduction of books and writing to a son of the king of Corea named Atogi, who came on an embassy to the Mikado's court in the fifteenth year of Ojin, that is, about A. D. 286, remaining one year. On his return, by invitation of the court, a teacher named Wani came over to Japan. Some say he was a Chinese from the kingdom of Go. He crossed the sea, and introduced the system of pronunciation still called Go-on. Many of the nobles and chief men now began to study Chinese books. For over three hundred years the Go-on pronunciation was the fashion.

About A. D. 605 it had become the custom for young Japanese students to go over to China and study there, as American lads often do in Europe. Five young men who had spent a year at what is now Singan, in Shensi province, China, on coming back home introduced a new style of pronunciation, called the Kan-on. After twelve hundred years we find that the Kan-on has supplanted the Go-on. The literary and scientific men, government officers and newspaper editors all use the Kan-on, while the Buddhist priests and common folk still employ the older pronunciation. The To-on, another method, which is like the modern Mandarin dialect of China, is but little used. These changes of pronunciation remind us that in England the Anglo-Saxon, the Latin, and the Norman fashions had each its day, before modern English was formed.

All this — that is, three or four different kinds of pronunciation, and the varying forms of speech, differing according to whether language is spoken or written, uttered by inferiors or by superiors — makes it very hard for a foreigner to learn the Japanese language thoroughly.

When at first the Japanese began to write their own language, it was to them very much as if we should try to express English with the characters copied from a tea-box. For one can write English with the Chinese characters as well as he can write Japanese. The islanders had at

first a hard time of it, trying in clumsy fashion to make the strange writing stand for Japanese ideas and words. It was a good deal like training an elephant to walk on his hind legs; for Japanese words are long and musical, while Chinese words are as short as in baby talk. The way they did it was to take Chinese letters that sounded like or something like Japanese, and make them do duty for their own vernacular. This was very much as if we made the different parts of a charade or rebus serve our purpose. For example, if we wished to write such a word as "tremendous," and should make a picture of a *tree*, some *men*, and a *dose* of medicine, serve our purpose, we should not be doing very differently from the early Japanese. Indeed, the first attempts at writing of nearly all ancient nations were very much like trying to play charades on paper; only, instead of its being fun, it was slow and toilsome work. Nevertheless, the Japanese persevered, and their first books were all written in this way, that is, the phonetic way, or according to sound. Hence the Kojiki, or Japanese Bible, though expressed in Chinese characters, cannot be read by a Chinaman, any more than we could read a telegram in cipher, though the words were in English.

Suppose that an American in Europe had arranged with his friends in New Orleans that "theosophy" should mean *send*, "capitulate" mean

me, " Webster " mean *ninety*, and " cataract " mean *dollars*. Then the telegram, " Theosophy capitulate Webster cataract," would be interpreted, " Send me ninety dollars." This is about the way the Kojiki is written, and a literal rendering into Japanese makes a jargon just like a cipher message. Only by the long study of many scholars have its secrets been unraveled. Even yet the translation of many of the sentences is very uncertain.

Thus it happened that the Japanese letters took the form, not of an alphabet in which each letter stands for a sound, but of a syllabary, in which each letter stands for a syllable. There is no B, C, or D, etc., in Japanese, but there are Ba, Be, Bi, Bo, Bu ; Da, De, Di, Do, Du, etc., and the syllabary makes forty-eight letters. By means of little dots or marks which change, for example, *ha* into *ba* and *pa*, seventy-three syllables may be represented. Curiously enough, in China, Japan, and Corea, we have illustrations of the only three ways in which language is written; the ideographic, the syllabic, and the alphabetic. The Chinese use characters, the Japanese syllables, and the Coreans letters.

For hundreds of years the Japanese had not even a syllabary, but went on writing laboriously the Chinese, doing the mighty work and performing the heavy tasks which an alphabet might have saved them. Then in the eighth century, just a

thousand years before our Declaration of Independence, a nobleman named Kibi invented or perfected the system of borrowed names called *kana*. This meant that he took only parts of the cumbrous Chinese characters to serve for letters, thus saving at each writing from two to ten strokes of the brush or pen; and so a set of forty-eight side-letters, as they are called, came into use. To this day, these are used in dictionaries to spell foreign names. These are like our children's letters which they print before they can write. To get some general idea of what they are, we have only to look at $, the sign for "dollars," *lb.* for " pound," &c. for "and so forth," or to the many special signs used in almanacs, astronomy, proof-sheets, music books, and in business writing. Yet the *kana* can represent exactly neither a Chinese nor any other foreign word. When the results of the Republican and Democratic conventions of 1884 were telegraphed from the United States to Japan, the newspapers in Tokio announced that the American presidential candidates were Boo-ra-nŭ and Kee-ree-boo-ran-do, that is, Blaine and Cleveland were the names of the candidates. This is the nearest the Japanese could come in their writing. Double letters in a foreign language puzzle both the speaker and the writer. When I lived in Echizen my name was usually pronounced like the word " grease," or, in full, Wee-ree-ya-mŭ E-ri-yo-to Gŭ-ree-su. Another varia-

tion was Gee-ree-wa-i-su. As the Chinese have
no "r," so the Japanese have no "l."

Our children first learn the printing and then
the writing letters; but to use a pen and write
quickly, the letters must be run or joined together.
The Chinese call these "grass" characters. It
was a great step of progress when the clever priest
Kobo, who died A. D. 835, invented or improved
the *hira kana* or easy letters, by which one could
write a long word, like "Onogoroshima," without
lifting the pen off the paper of the copy-book.
Kobo, who had traveled and studied in China,
was so learned, and was such a famous fellow
with the pen, that the funny artist Hokŭsai pic-
tures him as writing on a tablet with five brushes
or pens all going at once. One is held in his
mouth, and one by each foot and hand. This is
like the tradition in the Koran, that Ezra, the
Jewish scribe, could write with five pens in his
hand at once. Kobo has also the credit of ar-
ranging the Japanese syllabary, or *i, ro, ha*, into
the form of a stanza.

For centuries the Japanese children have read
this stanza and committed it to memory. It
often took many tears and many prayers to Mi-
chizané, or Ten-jin, for the little fellows to master
it, and, when done, it expressed a rather gloomy
thought. Since even Kobo had to do some twist-
ing to get the syllables into a form of Japanese
doggerel (for it is not real poetry), perhaps we

may be excused for hammering them into an English jingle : —

> Love and enjoyment disappear :
> What in our world endureth here ?
> E'en should this day in oblivion be rolled,
> 'T was only a vision that leaves me but cold.

For many centuries books were composed only in Chinese characters, and learning was confined chiefly to noblemen and people about the court. In modern times, books for the people, and especially women and children, have been written in *kana*, which all can understand.

One curious effect, largely due to the use of writing and the habit of spelling, was seen in the change of pronunciation of geographical names. In the course of centuries, even before the habit of writing was common, the old-time names of mountains, rivers, plains, and other landmarks were altered into the modern forms which we now see on the maps, and hear on Japanese lips.

Mr. Skeat, in his etymological dictionary, has pointed out the enormous influence which English spelling has exerted on the pronunciation of names and words. Of course, those words which are used every day do not change in sound, but those only occasionally spoken will sooner or later be pronounced as they are written. This we see in English, which consists so largely of words which have come down from our Dutch and German ancestors, or, as we say, " Anglo-Saxons."

In Japan, such a change proceeded with ten-
fold power when, by the imperial order and in
the official language, the geographical names were
written in government documents. The names
were expressed in Chinese characters, but these
were pronounced, not as the Chinese pronounce
them, but only as Japanese throats and lips could
utter them. Even the country folks had to speak
the old names in the new way. When they could
not, the names were altered to a fresh form.
Then all must pronounce in the standard way, or
be considered vulgar and boorish.

A kind of census was made, and an encyclopæ-
dia or gazetteer of all the known places in the
empire was compiled by order of the emperor as
early as the eighth century. From that time
forth, the polite or proper pronunciation of the
name of a place was that used at the court, ac-
cording to the characters with which it was writ-
ten. In the ninth century, when the *kana* or al-
phabet came into use, spelling, or expression of the
separate sounds of a word, became fashionable.
Then foreign words from Corea and China, or the
names and sounds from the lips of the distant
savages or uncouth people up in Yezo, could be
written. Of course they could not be reproduced
exactly as uttered, but they were pronounced after
a fashion by the lords or ladies of the court, and
this court or scholar's pronunciation became the
standard one. It is true that the people might

use the local names of mountains or rivers somewhat differently, but as this was looked at by the men who made the books, laws, and literature as vulgar, the written form gradually but surely became the correct one. In the course of centuries, many of the unwritten, aboriginal, archaic, and local pronunciations would also change. Thus it happens that the old Ainu names of mountains or rivers, places and landmarks, can hardly be recognized in the modern names given them.

A fresh element of trouble to the student arises from the fact that the Chinese characters, first used to write the names, were chosen only for their sounds; but now, being accepted for their meaning, confusion reigns and the old Ainu meaning is lost. This, however, gives the Japanese an opportunity for endless discussions, jokes, and puns. Often it is as though one acted a charade, or wrote a rebus by making a picture of a dog, a mat, an eye, and a girl, and pronounced it " dog-mat-i-gal," thus deriving the Greek word " dogmatical." One may here recall De Quincey's mock derivation of " Alexander the Great " from " all eggs in the grate "! In spite of their changed form and sound, the geographical names, like those given by the red Indians to Wachusett or Niagara in America, are the oldest of all. What the original meaning of many of the province names is, not even the most learned Japanese scholars can tell; but while they are modestly dumb, folks who go by the Chinese

characters and have a smattering of learning offer all sorts of explanations.

The people conquered by Yamato Daké were then called Émishi, which is the same as the modern word Yébisu. The letters M and B are about the same in Japanese. All eastern Japan was anciently called Yezo, or the uncivilized region, a name now applied to the great northern island. Kuanto, or the Broad East, another name anciently given, is still used. It means that part of Japan east of Kioto, and especially east of the great mountain-chain which may be called the spinal column of Hondo.

After Kioto had been made the capital, the provinces were named with reference to their situation to the front or back of the imperial city. So we find, among the fourteen old provinces with names ending in *zen* or *go* — that is, fore or behind, front or rear — several pairs, such as Hizen and Higo, Uzen and Ugo. There are also several groups of three, which besides the endings *zen* and *go* have the middle term *chiu*, which means "central." Thus Echizen is the Echi (or the sunny place) fronting Kioto; Etchiu, the Echi in the middle; and Echigo, the Echi at the rear. Others end in *no*, which means "moor" or "plain"; in *to*, "road, or "path"; in *yama*, "mountain." Others, in addition to the old native name, now more or less obscured, have a second or alternate form ending in *shiu*, a Chinese word,

as Satsuma or Sasshiu; Nagato or Choshiu, —
naga and *cho* both meaning "long."

The whole empire was arranged into *do*, or re-
gions, like our Eastern, Middle, Southern, or
Western States. First of all came the Gokinai,
or five home provinces, the old ancestral seats of
the Yamato clan, in which are the old capital and
graves of the Mikados, and out of the soil of
which the oldest antiquities are dug up for the
museums. Next comes the Tokaido, or Eastern
Sea region, in which are fourteen provinces facing
the sparkling waves of the Pacific Ocean. The
Tokaido stretches from the old homeland to Hita-
chi, which is north of Tokio, and in which is the
famous city of Mito.

Northward from the Tokaido, and running
between the great central mountains and the
sea, is the Tozando or Eastern Mountain region.
Coming down on the west and colder side of
Hondo, the Hokurikudo, or North region, lies
between the mountains and the sea. Thence we
still go southward, and, fronting China, we keep
in the Mountain Back region, that is, in the
shade of the morning sun. If we were on the
strip of provinces fronting the Inland Sea and the
east, we should be in the Mountain Front, or
sunny side.

Of those six provinces most of which are
scoured by the Black Current, four are in
Shikoku. They are named the Southern Sea

region. All the nine countries of Kiushiu Island are called collectively the Western Sea region. Then there are the "Two Islands," Iki and Tsushima. Further down, in the sunny south, is the Riu Kiu group of islands, the old "Eternal Land" of Japanese mythology. The group called Okinawa, or the Long Rope, is literally the tail-end of the empire, while up in the Northern Sea region are the storm-swept and foggy Thousand Islands stretching to Kamschatka.

Another practice fostered by the art of writing was the bestowal and use of posthumous titles upon famous persons. In the eighth century, when the old legends, songs, poems, and liturgies were committed to writing, the first Mikados, gods, heroes, and renowned ancestors received high-sounding names, which henceforth became common in conversation. It must not be supposed that the people who saw and fought or hunted with Jimmu Tenno ever heard of such a name or title; but, a thousand years or more after his death, or at least after the time in which he is supposed to have lived, this title was invented, being composed, like most if not all of such posthumous names, of Chinese terms mispronounced by Japanese.

CHAPTER XI.

In the early centuries the sons and descendants of the Mikados had no special family names. In China it is the rule that in every generation a step lower is made, until in the ninth generation the descendants of the emperor mingle with the people. In early Japan, the families of imperial blood took the general name of O, meaning "king" or "royal," which name was dropped after the fourth generation.

After this, special names, like those of Tachibana, Sugawara, Fujiwara, Minamoto, Taira, etc., were bestowed by order of the emperor. In the development of their history it was seen that certain employments, duties, offices, and professions became hereditary in particular families. Literature and education were monopolized by the Sugawara and Oyé, law and jurisprudence by the Miyoshi and Kotsüki, medicine by the Waga and Niwa families. There were other families still more famous in war and politics.

The most renowned line of soldiers was that of the Minamoto. The founder of this family or clan was Tsunémoto. He was the grandson of

the Mikado Séiwa (839–880). The Minamoto family crest is made by arranging three gentian flowers above the same number of bamboo leaves. Their battle standard was a white flag, and their favorite color was white. Many noble families, and all the great Shoguns and Tycoons who afterwards ruled at Kamakura or Yedo, claimed descent from the first Minamoto, and after A. D. 1192 no one could be a commander-in-chief or general unless he were of this stock. The shorter or Chinese form of the name is Genji. The Genji grew to be a mighty clan of many thousands of adherents, like those of the White Rose in English history.

The Taira was also a military family. The Chinese form of the name is Heiké. Their crest was a butterfly, and their color or banner was red. The family was founded by Takamochi, a great-grandson of the Mikado Kwammu (782–805). In the twelfth century, when at the height of their power, they numbered many thousands, like those of the Red Rose of England. Like the rival houses of York and Lancaster, the whites and reds, or Genji and Heiké, were rivals and at feud.

Gradually, also, a system of heraldry was developed, and each of the noble families had crests or badges. By intermarriage, these crests grew to be something like European coats-of-arms. As, however, the Japanese fought with two-handed

swords, they could not use shields. Hence the blazonry so complex in Europe, and which the knights usually quartered on their shields, was with the Japanese chivalry very simple. Usually it consisted of a flower, an animal, or some simple device easily recognized.

Of the families celebrated for their civic abilities, the Fujiwara was the most conspicuous. The name means Wistaria-meadow, and was granted to their ancestor in the year 670. This pretty blue flower, now common in our country as a house or wall vine, blooms in May before its leaves are developed. The first syllables of the native name sound like those of the mountain Fuji, or Fuji Yama, and the foreign name is from that of Dr. Wistar, of Philadelphia. The Fujiwara family was founded by Nakatomi, an adviser of the Mikado, said also to have built a storehouse at Kamakura. There are now five families nearest the imperial family itself, and from which the empress is taken, that are descended from the original Fujiwara stock. Unlike the Minamoto and Taira, the Fujiwara nobles never coveted land or military honors, and so were not subject to feuds or wars.

We have told of the Sugawara line of scholars. Another famous family is the Tachibana, founded A. D. 736, from which the tutors of the imperial children have usually been chosen. There are other noble families who are descended from Mikados, and were formerly called *kugé*, or court

nobles; but the four families mentioned are the most famous in history.

While the leading men of the Genji and Heiké were usually far away from the capital, fighting savages and extending the boundaries of the Mikado's empire, the Fujiwara men became the successful politicians at home in the palace. Putting in practice the American motto that "to the victors belong the spoils," they filled most of the offices with their sons and nephews. Further, they acted very much as successful political parties do everywhere. Not satisfied with having their relations in the offices already in existence, they created new ones for the men of their clan.

In the year 888, the title of Kuambaku, the highest in the land, was created and conferred on a Fujiwara noble. The word refers to the bolt on the inside of a door, and this Japanese Saint Peter could thus pull back the bolt and admit to the Son of Heaven only those whom he was pleased to favor. Only on the throne was the Mikado greater. It was not long before this great office was made hereditary in the Fujiwara family. Their ambition made them dictators of the throne, which in time they practically owned. This success they secured by marrying their daughters to the Mikados, and for centuries the empresses were of Fujiwara blood.

We must not, however, suppose that all the Genji and Heiké were soldiers, or that every

Fujiwara courtier was a politician. On the contrary, many famous authors and artists bore these names. Indeed, it may be said that as early as the seventh century the art of painting was well established at Nara, and that by the tenth century the native style, so brilliant in color and often as fine as miniature-painting, more like the Persian than the Chinese, and called the Yamato or pure Japanese method, was the reigning fashion. This is well proved by the novel called the Genji Monogatari, in which the lady author describes the competition of the painters and the award of the judges.

Probably the first and greatest of the early native painters was Kanaoka, who painted the portraits of Chinese sages and Buddhist saints, besides landscapes, figures, and horses. Although few of his great works have survived, his fame is kept alive even in the mouths of the common people by those legends which the monks and story-tellers so loved to tell. It is said of a horse painted on a screen in a temple near Kioto, by Kanaoka, that at night it would quit its frame and gallop wildly over the farmers' rice-fields. The country folks found out the devastator of their land by noticing the mud that clung to the hoofs in the picture. They put out the eyes of the picture, and after that Kanaoka's horse made no more night excursions. Another of the same artist's painted horses had the habit of roaming

in the imperial treasury gardens, and eating up the plant we call the Japan clover. In this case, instead of blinding the painted creature, it was fastened within its frame by painting a halter. Other similar stories tell of a cuckoo, painted on a fan, which uttered a note every time the fan was opened; of Tsunénori's lion, that made the dogs bark and fly at it; and of Sesshiu's rats, changed from ink and water into scampering bits of flesh and blood. Even the old story of the fight between the lion and the unicorn has its parallel in Japan. The carved wooden lion and the Koma-inu or Corean dog — a hideous creature seen in stone in front of Shinto temples — once fell to quarreling, one knocking the other down to the ground. Stories like these are told about many famous statues, pictures, carvings, swords, writings, and indeed about almost all things that are considered works of art in Japan.

Between politicians and priests, and their own desire to cultivate art, the Mikados had little to do with actual government. Often they were mere boys; or, after reigning a few years, they shaved off their hair and became cloistered monks. Often they had personal ambition to become artists. Some lived privately in debauchery. Many of them spent their days in the study of Buddhism, and in the enjoyment and patronage of art and letters. As, however, the emperor became of less importance as a person or a ruler, his honors

and dignity were magnified to the common people, to whom he became gradually invisible. He lived behind a curtain, and was seen only by his wives and women of the court, and by his high ministers. His feet were supposed never to touch the earth. To common folks he was a god. Even when he rode out to see the flowers or a waterfall, or to attend a poetry party with his courtiers, the chariot or cart, drawn by bullocks, was closed with curtains made of bamboo; and the place where he lunched or wrote verses was inclosed with woven stuff. In short, the real power of government was in the hands of the courtiers of the palace, while that of the emperor was very nearly a cipher.

CHAPTER XII.

SOCIAL LIFE IN KIOTO.

SOCIAL life in Kioto was the standard for that in good society everywhere throughout the empire. Etiquette was cultivated with almost painful earnestness, and the laws about costume were equally rigid. Tea was introduced into Japan by a Buddhist priest in the year 805, and soon became a common drink. The oldest tea plantations and the most luscious leaves are at Uji, near Kioto. The preparation and serving of the beverage were matters upon which much attention was bestowed. The making of cups, dishes, and all facilities for drinking was greatly stimulated by the use of the hot drink, and when the potter's wheel was brought over from Corea the ceramic art entered upon a new era of development.

Flowers and gardens were much enjoyed, and visits of ceremony were many and prolonged. The invention of the fan was not at first thought to be an aid to good manners, but it soon won its way to favor. As early as the seventh century it came into use for personal comfort. In course of time the fan developed into many varieties. The *kugé*, or court nobles, had one kind, and the

court ladies, with their long hair sweeping down
their back to their feet and arrayed in white and
crimson silk, had another. In art, we see that
the Dragon-queen of the Under-world holds a flat
fan with double wings. The long-nosed King of
the Tengus, or mountain sprites, who is said to
have taught Yoshitsuné his wisdom and secrets
of power, holds a fan exactly like the old pulpit
feather fans which it once was thought proper for
clergymen to make use of. The judges at wres-
tling matches flourish a peculiar sort, while in war
the wight who received a thwack over the noddle
with the huge iron-boned fan might lie in gore.
The firemen of Kioto, and the men in the proces-
sion in honor of the Sun Goddess at Isé, carry
fans that would cool the face of a giant.

The earliest fans were all of the flat kind, but
in the seventh century it is said that a man of
Tamba, seeing that bats could fold their wings,
imagined that the motion and effect could be imi-
tated. Accordingly he made the *ogi*, or fan that
opens and shuts. This was a great advantage,
securing economy in space and ease of use. An-
other story declares that when the widow of a
young Taira noble, slain in the civil wars, retired
to a temple to hide her grief, she cured the abbot
of a fever by fanning him. Folding a piece of
paper in plaits and then opening it out, mutter-
ing incantations the while, the lady brought great
prosperity to the temple, for thereafter the priests

excelled in making folding fans. From the sale
of these novelties a steady revenue flowed into
the temple. In time the name of this temple was
adopted by fan-makers all over the country. As
a shelter of the face or bare head from the sun, —
for hats and bonnets were not fashionable in Old
Japan, — for use as trays or salvers to hand
flowers, letters, or presents to friends or to one's
master, as thoughtful defenses against one's breath
while talking to superiors, and for a thousand
polite uses, to say nothing of its value as an arti-
cle of dress, the folding fan is a distinctly Japa-
nese gift to civilization. It had many centuries
of history and honor in Japan before the Chinese
borrowed the invention. In the caste of fashion
the flat fan, which too often sank to the level of a
dustpan, grain-winnower, or fire-blower, is in the
lowest grade.

The chief food, as well as the ceremonial drink,
came from rice. This grain was imported from
Corea, and very early became the standard article
of diet among the upper classes. The Japanese
have never yet learned to like bread, nor is rice
usually the food of the poorer people. The best
rice is raised in Higo. It is cooked, served, and
flavored in a great variety of ways, and many
extracts and preparations, such as gluten, *mochi*,
or pastry flour, and alcohol, are made from it.
The making of saké, by which we mean beer,
wine, or brandy made from rice, is as old as the

first commerce with Corea. It was the favorite drink of Japanese men and gods. The festivals in celebration of the planting, reaping, and offering of rice in the sheaf, or hulled and cleaned, and of the fermentation or presentation of the liquor to the gods, form a notable feature in the Shinto religion.

This saké or brewed rice was the drink enjoyed at feasts, poetry parties, picnics, and evening gatherings. Like tea, it was heated and drunk when hot. Besides the pleasures of music, poetry, and literature, cards, checkers, games of skill and chance, of many kinds, even to the sniffing of perfumes, helped the hours of leisure to pass pleasantly.

Outdoor sports were also diligently cultivated by these elegantly dressed lords and ladies of the capital. The ladies amused themselves by catching fire-flies and various brilliantly colored or singing insects, by feeding the goldfish in the garden ponds, or viewing the moon and the landscape. The delights of the young men were in horsemanship, archery, foot-ball, and falconry. The art of training falcons to hunt and kill the smaller or defenseless birds was copied from Corea, and has been practiced in Japan somewhat over a thousand years. Cock-fights, dog-matches, and fishing by means of cormorants were also common. A method of racing and shooting from horseback at dogs, with blunt arrows, was

cultivated for the sake of skill in riding. Polo is
said to have come from Persia into China and
thence to Japan, where it is called ball-striking,
or *da-kiu*. A polo outfit with elegant costume
and the liveliest of ponies was costly, so that polo,
like hawking, was always an aristocratic game.
The Warrior's Dance has been described as a
"giant quadrille in armor." The more robust
and exciting exercise of hunting the boar, deer,
bear, and other wild animals was often indulged
in by the military men in time of peace, in order
to keep up their vigor and discipline. In hunt-
ing, the bold riders and footmen could have some-
thing like the excitement of war with only a small
amount of its danger.

This curious social life in old Kioto is quite
fully shown in Japanese art, in books and pictures,
and the theatre, and is a favorite subject for the
poets, novelists, and artists. On fans, paper nap-
kins, lacquer ware, carved ivories, bronzes, sword-
hilts, and all the rich and strange art-works of Old
Japan, this court life can be pleasantly studied.
It was a state of things which existed before feu-
dalism came in completely to alter the face of the
Mikado's empire, and before Chinese learning,
pedantry, and literary composition cramped the
native genius. He who understands the method
and meaning of the artist has a great fund of
enjoyment. The painter and carver, or even the
decorator on a five-cent fan, tells his tale well, and

one who knows Japanese life from its ancient and mediæval literature, as well as by modern travel and study, needs no interpreter.

Best of all, however, life in the Mikado's capital is reflected in the classic fiction written in the Middle Ages, and mostly by ladies of the court. From a literary point of view, the women of Japan did more to preserve and develop their native language than the men. . The masculine scholars used Chinese, and composed their books in what was as Latin to the mass of the people. The lady writers employed their own beautiful speech, and such famous *monogatari*, or novels, as the Sagoromo, Genji, Isé, and others, besides hundreds of volumes of poetry in pure classical Japanese, are from their pens. A number of famous novels, the oldest of which is the Old Bamboo-cutter's Story, which dates from the tenth century, picture the life and work, the loves and adventures, of the lads and lasses, priests and warriors, lords and ladies, in this extremely refined, highly polished, and very licentious society of Kioto a thousand years or less ago. Those who would study it carefully must read Mr. Chamberlain's "Classical Poetry of the Japanese," or Mr. Suyé-matsŭ's "Genji Monogatari." Miss Harris's "Log of a Japanese Journey" is a rendering in English of the Tosa Niki, or diary of the voyage from Tosa to Kioto of the famous poet Tsurayuki.

The Tosa Niki book is a great favorite with

native students on account of its beauty of style. Tsurayuki was appointed by the Mikado to be governor of Tosa. After serving four years he starts homeward for Kioto by ship and carriage, or rather by junk and bullock-cart. He left Tosa in January, A. D. 935, and the diary of his voyage is written in woman's style of writing, that is, in pure Japanese. He calls himself " a certain person," and is a jolly good-natured fellow ; always, when opportunity serves, writing poetry and enjoying the saké-cup. As Japanese junks usually wait for the wind, sail only in the daytime, or at least not all night, and keep out of storms if possible, he stopped at many places, where official friends called upon him, and presents were exchanged, cups of saké drunk, and poems written. Most of the presents had verses tied to them, but the pheasants had a flowering branch of the plum tree attached. We translate a stanza : —

> "As o'er the waves ye urge,
> While roars the whit'ning surge,
> Louder shall rise my cry
> That left behind am I, — "

whereat the traveler notes in his diary that the poet must have a pretty loud voice. He tells of the storks and the fir-trees which have been comrades for a thousand years ; how the passengers went ashore at one place to take a hot bath ; how a sailor caught a *tai*, or splendid red fish, for his dinner ; jests at the bush of the man in the moon ;

throws his metal mirror into the sea to quiet the storm raised by the god of Sumi-Yoshi; escapes the pirates, with whom he had as governor dealt very severely; and completes his sea journey, not at Osaka, which did not then exist, but at Yamazaki, near the capital. There he waits for a bullock-car to come from Kioto, which he must of course enter in state as becomes a *kugé*, or noble.

This charming little book shows first that human nature in Japan a thousand years ago was wonderfully like that of to-day in Japan, or anywhere else; that good style will make a book live as long as the rocks; and that in those days the spoken idiom differed very little from the language employed in literature. Brave Tsurayuki! He wrote in "woman's style" really because he loved his native tongue, and did not want to see it overlaid by the Chinese. In our days not a few Japanese are heartily ashamed that their own beautiful language has not been more developed by scholars. So much dependence on China has paralyzed originality and weakened intellect. After fifteen hundred years, the patriotic Japanese feels ashamed that the literary and intellectual product of his country is so small, and that the best work in his native tongue has been done by women. No wonder he does not always take kindly to the fulsome flatteries of Europeans who tell him what a wonderful fellow he is, and how

much superior Japanese civilization is to that of Europe! How he really feels about the matter is shown in his eager desire, on the one hand, to absorb all the ideas and adopt all the inventions of the foreigners, and, on the other, to bridge the gulf between the spoken and the written forms of his own vernacular.

We must now turn from the scenes which prompted the devout patriot to bow in gratitude before the shrine of Heaven and give thanks for " peace within the four seas," and tell the story of civil war.

CHAPTER XIII.

THE WARS OF THE GENJI AND HEIKÉ.

FOR centuries the two soldier clans, the Genji and Heiké, had been busy in many wars, at the ends of the empire, until every tribe was subdued, and "all was peace under Heaven." They were jealous rivals, however, and had many quarrels among themselves. When campaigns were over, and the leaders came to live in Kioto, they began to think that it would be a good thing to possess the palace, and the Mikado, and the fat civil offices, just as the Fujiwara nobles had done. The Japanese "Wars of the Roses" began in the twelfth century. The Taira clan was then led by a man of great talents and power named Kiyomori. The head of the Minamoto house was Yoshitomo. In the year 1156 these clans quarreled and came to blows while trying to get possession of the imperial palace. The Minamoto were beaten and driven out of Kioto.

The Taira men, having won the palace, now dictated the policy of the emperor, and all Japan was virtually under the control of Kiyomori. In 1167, when fifty-six years old, he reached the highest office which a subject in Japan could obtain. He

was made Dai-jo-Dai-jin, which means the Great
Government's Great Officer. He turned the Fuji-
wara men out of office and put in his own clans-
men. He banished nobles, built palaces, moved
the capital, made his daughter the wife of the em-
peror, and even dictated who should be Mikado.
To what higher point could he reach before being
called upon to "change his world," as the Buddh-
ists say, or, in common language, to die?

Drunk with triumph, he resolved to exterminate
the Minamoto. By means of hired assassins, and
orders sent to all the guards at the barrier-gates
built across all the great roads and mountain
passes, he seized, imprisoned, or slaughtered most
of the Genji leaders. To various parts of the
country, however, many Genji mothers fled, found
hiding-places, and reared their sons to manhood.
Tamétomo, the giant-like archer, had the muscles
of his arm cut, and was exiled. When his arm
healed up he escaped, sunk one of the Taira ships
sent to recapture him, and escaped to the Riu Kiu
islands in the far south. There, it is believed, he
became the father of Sunten, the first king of this
archipelago, the name of which means either the
Sleeping Dragon, or the Hanging Globes. In old
maps the name is printed Loo Choo.

In order to get possession of Tokiwa, the beau-
tiful concubine of the Genji leader Yoshitomo,
Kiyomori seized her mother. In Japan, the duty
of a daughter to her mother is considered greater

than that even to her children. Tokiwa the beautiful had fled with her three sons. The names of two of them, Yoritomo and Yoshitsuné, then a little baby, are among those most famous in Japan.

Dazzled by Tokiwa's beauty, Kiyomori not only saved the mother's life, but moved by her prayers, yet against the warnings of his retainers, allowed the three boys to live. Yoritomo was banished to an island off Idzu, then the Siberia of Japan. Yoshitsuné, when a few years older, was sent to a monastery near Kioto to be made a Buddhist priest.

The little boy, who had a ruddy face and a fiery temper, was so unmanageable and mischievous that the shavelings called him a "young bull." When the boy asked the monks to let him go up north with an iron merchant who lived in Mutsu, the brethren were only too glad to get rid of him. Yoshitsuné spent his life until past twenty-one in the service of a Fujiwara nobleman in out-door exercises. He thus became a soldier of highest reputation for courage, skill, and honor.

Yoritomo in exile grew up under the eye of two Taira officers who had been appointed to watch him. He trained himself to be patient and to control his feelings. He cultivated the virtues of courtesy, valor, and endurance. When grown to manhood he married a beautiful girl named Masago, whose father was Tokimasa, of the Hojo

family, who had vowed to help Yoritomo when his
opportunity should come.

Even when the boy Yoritomo was being taken
from Kioto into exile, the farmers who saw his
striking countenance said it was like letting a
tiger loose. In the year 1180, the time came for
the young tiger to make his first spring. The
tyrant Kiyomori in Kioto had become so insolent
that one of the imperial princes plotted to over-
throw him. He sent out letters to all the Mina-
moto retainers to rise in arms. Some refused in
scorn, saying it was like mice rising against a cat;
others gathered themselves together under the
white flag.

In the famous Hakoné mountains, Yoritomo
and the Genji men fought two battles. Although
beaten, more followers joined him, and he chose
the village of Kamakura as his headquarters.
Here, in the seventh century, so legend goes, the
ancestor of the Fujiwaras, when on a pious pil-
grimage, spent a night near the site, and in his
dreams was told by the *kami* or gods to bury or
lay in store a precious sickle which he carried
with him. He did so, and thus the place received
its name of Kama-kura, or Sickle-storehouse.
Here, also, at a place called "Crane Slope," only
a century before, Yoritomo's grandfather had built
a shrine to Ojin, or Hachiman, the god of war, in
gratitude for victory. Here Yoritomo laid out a
city and gathered his army. The place was easily

defended, for it lies in a valley inclosed by hills, and outlooking upon the seashore. There are entrances to it at each point of the compass, that from the north being a road cut through the solid rock.

Yoritomo marched to the Fuji river to meet the Heiké army, sent from Kioto against him. There his brother Yoshitsuné from the north and many others joined him. Before a battle could be fought the Taira host retreated. They were scared away at night, it is said, by the trick of a deserter, who went among the wild fowls on the river banks, and purposely drove the birds from their roosts. They made such a din with their wings and throats that the Taira soldiers, thinking it was on account of a night attack from their enemies, fled in disorderly retreat. Returning to Kamakura, the work of building the city went on, while the Genji recruits came pouring in. The whole East seemed now in a state of uprising, and the empire ready to burst into the flames of civil war.

Meanwhile Kiyomori lay dying in Kioto. When facing death, the great soldier's words were not like those of Christ on the cross, who prayed that his torturers might be forgiven, but of David, who commanded Solomon not to let his enemies reach their graves in peace. Kiyomori's only regret on his dying bed was, that he had not seen the head of Yoritomo cut off. " After I am dead," he com-

manded, " do not propitiate Buddha on my behalf, do not chant the sacred liturgies. Only do this, — cut off the head of Yoritomo and hang it on my tomb." This, however, was never done, for Yoritomo died many years afterwards with his head on.

The Minamoto army now moved from the east to the west, and resistlessly on to victory. The long civil war of five years had begun in earnest. The prize was Kioto and the imperial palace. After several bloody battles the city was won, a new Mikado set on the throne, and the property of the fugitive Taira confiscated. Their palace near Hiogo was captured by Yoshitsuné, who pursued them southward to the Straits of Shimonoséki, the place of repeated naval battles in Japanese history. Here, in May, 1185, led by Yoshitsuné, the fleet of the Genji attacked the vessels of the Heiké. While the Genji were all men and fighters, the Heiké were encumbered with their women and children. Over a thousand war junks were engaged under the opposing white and red flags, and the bloody battle lasted for hours.

In this, the greatest of sea-fights in Japanese annals, the Heiké as a clan were annihilated.

The Genji men took vengeance on their enemies and put to death hundreds of Taira boys. Many mothers fled to hiding-places, and some youths of Taira blood were reared to manhood, but changed their names. The women and many of the com-

mon soldiers and retainers were spared. In the month following, the victorious army enjoyed a triumph in Kioto. They exhibited their spoils and prisoners, and processions and festivals occupied many days.

The awful event at Shimonoséki made a great impression on the people, and especially upon the fishermen and sailors in the region of the great battle. In the temples at Shimonoséki there are striking pictures of the struggle.

Many are the legends which tell how the unquiet ghosts of the Taira raise storms, and appear to mariners at night. On one occasion, as Yoshitsuné in full armor was crossing the straits, the waves were lashed to fury by a tempest which threatened to founder the ship. The sails flapped wildly, and the ship refused to obey her rudder. Out on the tops of the curling spray stood myriads of pale-faced and angry shades of the dead. Ghastly with wounds, they threatened dire calamity to the victor who had sent their souls into the nether world. Yoshitsuné, undaunted, stood on deck, and with his sword struck vainly at the ghosts that would not down, cutting nothing but the air. Only when Benkéi, the gigantic priest-warrior, threw down his sword, and pulling out his beads began to exorcise the spirits by appropriate Buddhist prayers, did the storm cease and the shades disappear.

Even in our own day the fishermen tell stories

of ghosts which rise out of the sea at night and beg for a dipper. These ghosts are the Taira men slain in battle, and condemned by the King of the World Under the Sea to cleanse the ocean of its stain of blood. The boatmen always give them a dipper which has no bottom, else they would swamp the boat by filling it with sea-water. The restless souls, long ago condemned to bail out the sea and cleanse it of its stain of blood, still keep hopelessly at work.

The fishermen, however, say that the Taira ghosts, in these late days, only occasionally appear. For centuries after the battle they used to rise up in hosts. A great temple sacred to Amida, the Boundlessly Compassionate Buddha, was erected long ago at Shimonoséki to appease the wrath of the spirits. Since then they have been quiet. Evidently their ghosts have taken the shape of shellfish, as Buddhist doctrine teaches. A peculiar kind of crab is found in the Straits. On their backs may be traced the figure of an angry man. These are called Heiké-gani, or Heiké crabs, and the fisher folks say they were not known to exist here until after the Taira were slaughtered in the great battle. A few years ago plaques of copper, inscribed with the story of the conflict and a description of the crab, were sold to tourists. Many Japanese are fond of traveling to visit the sites of old battlefields, and places famous for scenery or described in poetry, and the copper-engravers drove a thriving trade.

When the Taira army fled from Kioto they carried off the Mikado and three sacred regalia, the mirror, ball, and sword. The little boy-Mikado Antoku, who was a grandson of Kiyomori, was put in care of his grandmother, Kiyomori's widow, who was a Buddhist nun. In the battle, the nun with the boy-emperor in her arms leaped into the sea, so as not to be taken alive. The boy's mother Taigo followed, vainly trying to save the child, and all three were drowned.

The three sacred emblems were recovered and brought to Kioto, but it was not until nearly three hundred years afterward that the great Taiko had a monument erected to the young Mikado's memory. It was placed on a ledge of rocks in the channel of the rushing waters. Several score of the Taira men who were not killed fled to the mountain fastnesses in Higo. Here their descendants have lived. Their very existence was unknown and unsuspected until about a hundred years ago, when it was discovered that in the veins of these secluded people, who lived roughly as hunters and trappers, ran the blood of the Heiké.

CHAPTER XIV.

WHILE part of the Kamakura army was fighting in the southwest, Yoritomo himself made a campaign in the north in Mutsu and Déwa. He was everywhere victorious; and now he who had left the capital as an exile, hardly certain of his life, rëentered Kioto in splendor and with a magnificent retinue. Both the reigning and the cloistered emperor received him with distinguished consideration. Every visit he made consumed several hours by the water-clock, showing how much the emperor delighted in him. When they saw his elegantly attired companions and their fine dress and manners, the old inhabitants of the city and the court nobles were surprised. They could hardly believe that such wealth and cultivation of the arts of dress, display, and etiquette existed in the east. They had supposed that part of the empire to be poor, and comparatively barbarous. They ought to have known better; for by this time the Buddhist priests had carried books and learning into many places in the north and east, while not a few civil and military men of noble descent had settled in various towns and

villages, taking their family names from the neigh-borhoods in which they dwelt. Many of them afterwards rose to great fame, as we shall see.

Yoritomo made costly presents, and after a round of feasting, festivals, and games which de-lighted the people and added to his popularity, returned to Kamakura loaded with honors, and with powers greater than any ever granted to a subject. In a word, when Yoritomo left Kioto the second time, instead of being an exile he faced the rising sun as the virtual ruler of all Japan. The military age of the Mikado's empire had begun.

The campaign against the Heiké was conducted chiefly by Yoshitsuné. During the war in the southwest, Yoritomo had remained in the east at Kamakura, busy in affairs of government, for he had a genius for statesmanship as well as for strategy and tactics. In his civil policy he was so successful that soon the robbers were put down, and the highways made safe for travel. The warlike Buddhist monks, who had made their monasteries little better than the castles of robber barons, were curbed, and good government every-where in eastern Japan succeeded to misrule. Yoritomo established a council of state, and tribu-nals for the trial of violent offenders. He encour-aged every one to offer suggestions or criticisms, and to propose improvements. The petition-box was always open to those who had complaints to

make. Soon it came to pass that the Kioto officers of the treasury, seeing how the tide was turning, came to live in Kamakura. Yoritomo eagerly availed himself of their experience to increase and husband his revenues. Thus it seemed as if the eastern town was to be the actual capital of the country.

Yoritomo craftily took every opportunity to extend his own and his family influence. His shrewd father-in-law, named Hojo Tokimasa, helped him. After the Taira had been annihilated, Yoritomo requested the Mikado to appoint five army officers, all Yoritomo's relatives, as governors of provinces. This was agreed upon. Yoshitsuné was at once made governor of Iyo.

This was a tremendous step towards feudalism and military despotism, that army officers should be set to rule provinces, instead of civil officers appointed from the court. Formerly, the double business of the civilian governors who were sent out from Kioto, and who held office for four years, was, first, to collect the taxes which formed the revenue of the government, and, second, to put down violence and rapine. When the imperial court appointed Yoritomo to be the Chief Constable of the Realm, he craftily proposed that the authority in each province should be divided, the civil governor attending to the collection of revenue, and the military governor putting down the robbers and rebels. Still further, he requested

that these military governors should be his own
relatives, and also that they should be under his
control from Kamakura. This double request
was granted, for Yoritomo's influence at Kioto
was tremendous. Had not his Genji ancestors
conquered nearly all northern Japan for the
throne? Was not his father-in-law in command
of the garrison at Kioto, and did not the Mikado
Gotoba owe his elevation to Yoritomo, and ought
not brave soldiers to be rewarded?

So, gradually, it was seen that, while the name
and shadow of government remained at Kioto,
the reality and substance were at Kamakura. In
1192, Yoritomo attained the zenith of honor, and
was made Séi-i Tai Shogun.

This long title means Rebel-Subduing Great
General. It had been in use nearly four hundred
years as a purely military title, but Yoritomo
made it mean more than ever it meant before.
In his hands and those of his successors it meant
Keeper or Mayor of the Palace, and the virtual
ruler of the country. The office and title lasted
until 1868. The Shoguns and Tycoons, who ruled
during nearly seven hundred years, all professed
to be following this precedent established by
Yoritomo. They were his successors, and of
Minamoto blood.

Kamakura now became a great city, and all
government was divided between the throne and
the camp. It was a duarchy, or double govern-
ment.

Yoritomo was one of the ablest men Japan ever produced. Yet he was in character jealous and cruel. He did not like it that Yoshitsuné, his brother, had won such brilliant victories, and was so praised by all. A man named Kajiwara poisoned the mind of Yoritomo with slander against Yoshitsuné. So, instead of welcoming his younger brother kindly, Yoritomo persecuted him to the death. Indeed, it was usually his way to handle cruelly those who had once served him. Selfish and heartless, his memory is execrated, while that of Yoshitsuné is honored.

To-day Kamakura is only a country town of about six thousand people. The foreign people of Yokohama make use of it as a seaside resort, or for picnics and excursions. Yet at one time, in its best days, it contained probably a million people. Where temples and palaces once stood, and splendid avenues ran, are now common rice-fields. The change reminds us of the site of Matildaville, on the Potomac, planned by Washington as a city, once gay with elegant ladies and gentlemen, populous with workmen, slaves, and rich proprietors, and promising wealth with its mills, river-dam, and canal, but now unknown to history or gazetteer, and visited only by tourist or picnic parties.

So Kamakura is given over to quiet country life, and all that tells of the great Yoritomo is a simple obelisk tomb on the top of a knoll. Yet such

was the splendor of these old days that the Japanese of to-day fires his imagination as he visits the shady groves and hill-passes. Poet and novelist still delight to locate the scenes of their romances amid the pagoda shadows, and spectacular splendors, and processions of the Kamakura of the twelfth and thirteenth centuries.

The artist, also, has his own way of picturing the glories of the place, and the prosperity attending the rule of Yoritomo. Hokŭsai, the great artist, who died only a few years before one of Commodore Perry's ships, the Macedonian, grounded off Kamakura, has in one of his albums a famous picture of the cock on the drum.

In European art, the symbol of peace is a white dove, an olive branch, a lamb, a flower-grown cannon on the neglected battlefield, a radiant maiden, or an angel in glistening white robes. In the art repertoire of Japan, it is a crowing cock standing on a drum raised in air.

This is what we may call the æsthetic resurrection of a custom long dead, and known only in history. We are reminded that long ago, in Kioto, by the emperor Kotoku (645–654), the custom was established, and afterwards copied in Kamakura. A wooden drum stood on a post in front of the office of the magistrate. Whoever was oppressed or maltreated, and wished to present a petition for redress, sounded the drum. Then the guard came out to receive the petition

or relieve the plaint. In times of misrule and bad government the drum would sound often, scaring away bird and beast. In time of peace and good government, when all dwelt in happiness and no one was injured, the alarm drum was neglected, and, no one being near it, the cock could mount it as a crowing-place. Hence this figure of the cock and drum, so often noted in museums where Japanese art is exhibited, is a symbol of good government.

After long years of peace the parchment of the drum would decay, and even fall to the ground. The motherly old hen would lay her eggs and hatch her brood within. Even the doves would coo and bill upon the top. In Hokŭsai's sketch of the neglected drum, the vines encircle it, the flowers bloom, and the doves hover over it, the sign that all the empire was at peace. Loyal and true to the Mikado, Hokŭsai makes the leaves of the encircling shrubbery and their flowers those of the *kiri* and the chrysanthemum-tree, — the floral emblems of the imperial rule and family.

CHAPTER XV.

THE DEATH OF YOSHITSUNÉ.

It is a sad page of Japanese history which tells of Yoritomo's treatment of his younger brother. We do but imitate the native historians in telling of it.

Alas for human ingratitude and jealousy! Alas for him in whose heart rankles the double-bladed arrow of slander! In the ear of Yoritomo was poured the flood of falsehood that washed out affection between blood and bone.

It was the Japanese version of Romeo and Juliet, of Montague and Capulet. Yoshitsuné while in the south had loved a daughter of a noble of Heiké blood, and had married her. He had also offended a certain military inspector named Kajiwara Kagétoki by never asking his advice. This enraged the inspector, who returned to Yoritomo and slandered Yoshitsuné in every possible way. So the jealousy of his brother and the hatred of his enemy were as flint and steel to the suspicions aroused by his marriage with the Heiké lady. The fires were soon kindled that were to destroy the faithful, loyal, and brave Yoshitsuné.

Yoritomo would not allow him to enter Kama-

kura, nor even see or write to him. The fuel of
the poison-tongued liar fed the fire of jealousy in
Yoritomo's heart, and henceforth Yoshitsuné be-
came an outlaw, flying from the hatred and ven-
geance of his unnatural relative, who had deter-
mined on his death; for Yoritomo had said: "He
must be hoed up without mercy. Who will at-
tack Yoshitsuné for me?" He even erased his
name from the family rolls and changed his name
to Yoshiakira.

Yoshitsuné, now finding his life was in danger,
kept strict watch. One night a band of horsemen
in armor, each having a torch, surrounded the
house in Kioto where he was staying with only
fifty followers. Hastily putting on his corselet, he
rushed out, and charged into a storm of arrows
that blunted their heads on his hard armor, or
stuck in his lacings. Sword in hand, he drove
the enemy off in disorder, and then finished pur-
suit with bow and arrow. He then went straight
to the palace of the emperor, just as he was, and
reported the cruel attack. His helmet was as full
of arrows as a porcupine of quills, and he had only
three shafts left in his quiver.

To escape the plots of his brother, Yoshitsuné
fled to Yamato and took ship, but the storm drove
him back, and he landed and hid on land five days.
Even the priests now sought to kill him for reward.
Avoiding them, he reached Kioto again, and found
a hiding-place with a faithful retainer, one Sato,

who was also in concealment. One day, as Sato was playing checkers, a band of Yoritomo's men burst upon him, armed with swords, and long iron hooks to catch in his clothes and trip him, for they were afraid of his tremendous strength. But Sato, though armed only with the checker-block and pieces, seized one man and threw him in the air, grasped another by the neck and tossed him at his fellows. Then he hurled the heavy checker-block into the crowd, knocking over two or three men. As a final discharge, he threw the cups full of the three hundred or more black and white counters full in their faces. For a moment there was a hail-storm, but finally force and weapons overcame even his gigantic strength. Entangling him in their grappling irons they pulled him down, and hacked him to pieces with their swords. Then they carried his head to Yoritomo.

Yoshitsuné, finding he could not hide in Kioto, parted from Shidzuka, his beloved. This scene of his farewell is a favorite one with the artists. He and his faithful retainer Benkéi fled northwards in the disguise of mountain priests. After many days, he arrived at the castle of a Fujiwara noble, who gave him help and shelter. This old noble wished to see Yoshitsuné put down Yoritomo and become lord of Kamakura. But not long after, the old man died, leaving two sons, one of whom, by the order of Yoritomo, plotted against Yoshitsuné's life, and attacked the castle in which

Yoshitsuné with his wife and children and Benkéi were living.

How Yoshitsuné died is uncertain. The soldiers say that, after putting his wife and children to the sword, he killed himself. The soldiers then cut off his head, and sent it in a lacquered box full of strong wine to Yoritomo, who at the time was celebrating a temple feast and therefore would not examine it.

Others say that Benkéi made an image of himself, stuffed it with rice-straw, and at night fastened it securely on the bridge crossing the moat to the castle gate. In the morning, the enemy shot at it until it was as full of arrows as a cushion full of needles, while the spent shafts were piled in heaps on the bridge. They feared to come closer, as the garrison might be waiting ready to sally out. Finally, the towers and buildings inside were set on fire by means of flaming arrows, and the castle was forced and found empty. The Ainus say that Yoshitsuné fled to Yezo, and became a great lawgiver and mighty man among them ; and these people worship his spirit to this day. After living several years in Yezo, it is said that he fled across the sea to Tartary, and became the renowned Mongol conqueror, Genghis Khan, who filled two continents with terror, and founded an empire stretching from Corea to Poland, and from the Danube to the Yellow Sea.

Yoshitsuné, the brave, the generous, the loving,

the chivalrous, is the Japanese boy's model ; and
on the fifth day of the fifth month, when the im-
ages of Japan's illustrious heroes are set out in
festal array, none, saving the emperor's, receives
a higher place and greater honor than that of
Yoshitsuné, the stainless, the brave. Of all the
bright names on the long scroll of Japanese his-
tory and legend, no other name thrills the Japa-
nese boy's heart like the name of Yoshitsuné.

CHAPTER XVI.

WITH Kamakura a second capital, and the Shogun a real ruler, the Japanese government was a duarchy, and the general outline of the programme of Japanese politics was fixed for the next seven hundred years. Long before Europeans knew anything of Japan, from A. D. 1192 until within a few years ago, everything in Japan seemed to be double. There were two rulers, two governments, two capitals: the Mikado and the Shogun; the throne and the camp; the *kugé*, or court nobles, and the *buké*, or military lords. Practically, from 1192 to 1868, with but few exceptions in point of time, this was the state of things in Dai Nippon.

No subject, either nobleman or commoner, ever attempted to seize the throne and make himself emperor, but only to overawe the court, and dictate which heir of the imperial blood should occupy the throne. The Japanese had no foreign wars to wage, or invaders to contend with, but they quarreled among themselves, and often two rival parties fought to obtain possession of the person of the Mikado. Whichever one was victorious, and could execute its will in the name of the Son

of Heaven, was the "loyal" one, while the de-
feated party became *chō-té-ki*, or rebels.

In long eras of peace, this awful name and word
was forgotten, but in time of civil war, it sprang
upon the lips of the people, with all its horrible
associations of treason, attainder, blood-pits, heads
taken off with the sword, hara-kiri, or suicide, con-
fiscation and the waste and desolation that always
accompany civil war. Few countries have had so
many intestine wars and so much bloody slaughter,
both for political and religious ends, as Japan. It
is in poetry, not in fact, that it is called the "Land
of Great Peace." The truth of history and the
rhapsodies of hasty tourists are grievously con-
tradictory.

We shall be content with stating this general
assertion, without entering into the repulsive de-
tails of the reality. Instead of minutely describ-
ing the battles, as the native histories do, we shall
note the progress of the arts and sciences, and how
the civilization of the Princess Country developed.
Thus shall we see and know how Japan came to
be, first, the Lady among the Asian nations; then
the Princess Thornrose; then how she fell asleep;
and, again, how Prince Perry woke her up with
a rousing kiss; and, finally, how she lives and
dresses in modern fashion, arrayed in the costume
of both East and West.

Yoritomo had a fall from his horse in the year
1198, and died early in 1199, at the age of fifty-

three, after a rule of fifteen years. Yoriiyé, his son, succeeded. Yoriiyé was deposed by Hojo Tokimasa, his grandfather, and afterwards assassinated by hired assassins. Sanétomo, another son of Yoritomo, succeeded, but was beheaded in revenge for his father's death by Kugio, the son of Yoriiyé. The direct line of the Minamoto was now extinct.

Hojo Tokimasa, of whom we have spoken, was the seventh in descent from a Taira nobleman, who was a son of the Mikado Kwammu (782–805). Settling at Hojo, a town in Idzu, just south of the great Tokaido road, they took their name from this place, now a wretched little village.

Hojo Tokimasa had married his daughter Masago to Yoritomo, and by other intermarrages the Hojo and Genji clans were closely united.

Now began that part of Japanese history known as " the era of the puppet Shoguns." It was a game of Punch and Judy in politics. None of the Hojo men ever attempted to fill the office of Shogun, but their idea was to set up some one sent from Kioto as a mere figure-head, while they acted as regents, ventriloquized their opinions, pulled the wires, and exerted all real authority.

Masago, Yoritomo's widow, sent to Kioto and delighted the Fujiwara nobles by asking that a baby boy of their family name, only two years old, be sent to Kamakura and made Shogun. After twenty-five years of shadowy rule, he was

made to resign in favor of his son, six years old, who in turn was deposed when twelve years of age and sent back to Kioto.

After this, the Hojo politicians secured princes of imperial blood, sons of Mikados, setting them up when mere babes, and bowling them down, like ten-pins in an alley, when grown to be men, or when they began to show signs of manly independence.

Having the army and the treasury in their power, the Hojo were enabled to overawe the Mikado and court, terrorize all Japan, and put down all attempts to overthrow them. Finally, however, in 1333, two heroes arose to draw their swords victoriously against the Hojo, whose oppressions of emperor, court and people could no longer be borne.

Nitta Yoshisada was a captain in the army of the Hojo. In his veins flowed the blood of Minamoto ancestors who had settled at Nitta. Leaving the service of Hojo, he appeared before the shrine in his native village and called for volunteers to range themselves under his white banner. With his troops, he attacked Kamakura on three sides, stormed the barricades, captured and set on fire the city and left it in ashes. Six thousand of the Hojo retainers, it is said, committed hara-kiri. While thus successful in the east, two captains loyal to the Mikado arose in the west, and took Kioto. The name of one,

illustrious forever in Japanese history as the typical loyal Samurai, is Kusunoki; that of the other is associated with a new dynasty of Shoguns, Ashikaga Takauji.

The Hojo family now passed out of sight, as the Taira family had already done before them. As the memory of the Taira is preserved in the folk-lore and ghost stories of the peasantry and fishermen, so the Hojo have their namesakes in hated vermin. The country folks of eastern Japan have a great annual ceremony for the extermination of a destructive worm called the "Hojo bug," and thus keep alive the detested memory of the second line of rulers at Kamakura.

Many, also, are the puns and jokes on the word *hojo*, which means both a Buddhist priest or monastery and the setting free of live things that have been confined, such as animals, birds, fish, or insects. This the Buddhists consider meritorious work, as making offerings for the dead. In Tokio, I used to notice old women sitting on the bridges and selling young eels. These were bought by passers-by and immediately dropped into the canal below, in pious memory of deceased relatives, and to shorten their pains in the Buddhist purgatory.

Nevertheless, the Hojo rulers deserve the honors of history, for some of them were able statesmen. They improved justice, agriculture, and industry, or encouraged literature and religion. They

established a great library. The resources of the country were developed, and the nation grew richer. Under their patronage, splendid temples, monasteries, pagodas, and images were erected. The great bronze image of Dai Butsu (Great Buddha), and other grand edifices still standing at Kamakura, testify to their enterprise. One of them had the pagoda-shaped monument to the memory of Kiyomori erected near Hiogo. They kept alive the military spirit, and defended the country against the Mongol Tartars. They beheaded the insolent envoys sent over from China to demand that the Japanese declare themselves vassals of the great Khan. When, in 1281, the armada of Kublai attempted to invade and conquer the country, they were successfully driven off. The winds and the waves fought for the Japanese. Of the "Jimpu," or Divine Breath, the Japanese to this day speak as gratefully and piously as do the English of the providential storms that defeated the Spanish Armada. Japan, too, had her warriors, like Drake and Frobisher, who bravely defied and crippled the remnants of the enemy.

Indeed, the Japanese sword won new reputation from this repulse of the Mongol invaders. Instead of the ancient two-edged *ken* or falchion of the "divine ages," or of the clumsy and unwieldy weapons of the continental Asiatics, the Japanese now fought entirely with the long and slender sword made of both iron and steel. The

famous swordsmiths of the Middle Ages had
forged a new weapon made by setting an edge-
strip of hardest steel into a backing of soft, tough
iron made of the native magnetic sand, or ore.
Of this two-handed blade, called a *katana*, appa-
rently so light and delicate when laid beside the
heavy choppers of the Chinese, the Japanese are
intensely proud. Their feeling was like that of a
Kentucky rifleman of the olden time contrasting
his small calibre with the large, smooth bore of
the old ball-and-buck soldier's musket. From
this time forth, the names of the Southern Coun-
try of Brave Warriors, and the Kingdom Ruled
by a Slender Sword, and the Land of Many
Blades, applied to Japan, became common in
poetry and romance.

The feudal system developed and took on new
features under the Hojo rulers. They kept a gar-
rison in Kioto to overawe the court and emperor.
The term "Samurai" included all the military men
of the country, and the custom of wearing two
swords came into vogue, so that "two-sworded
man" and "Samurai" were equivalent terms.
The long sword was for use against the enemy,
and the dirk or short sword was for suicide.
When wounded in battle and unable to escape,
the soldier, in order to avoid falling alive into the
hands of the enemy, stabbed himself in the belly
with the short sword. This was called *hara-kiri*,
but the more elegant term is *seppuku*. Soon the

upper classes claimed it as a privilege to die in military style, just as a soldier, Major André, for example, prefers to be shot rather than be hanged. Instead of being beheaded on the common execution-ground like a vulgar criminal, and by the ordinary deathsman, the Daimio or Samurai condemned to death was notified when and where he might, in presence of the official inspectors, kill himself. In later times this was done with great ceremony, and a chosen friend made the action sure by decapitation.

The Hojo period (1219–1333) is also famous for the great missionary work and triumph of Buddhism. The country was visited to its extremest boundaries by preaching monks. The doctrines of Shinran and Nichiren, who reformed and expanded the faith imported from India, were propagated all over the country. It was during the Hojo era, also, that the existence of Japan under the name of "Zipangu" was made known to Europe through the writings of Marco Polo.

CHAPTER XVII.

BENTEN AND THE DRAGONS.

ALMOST all Americans who travel in Japan arrive first at Yokohama. They make their first trip to Kamakura and the beautiful island called Enoshima. Associated as these two places and the region around are with the Hojo, we have chosen a characteristic legend to illustrate the local folk-lore. The subjects here treated of are great favorites with Japanese artists.

Of the four thousand isles of Japan, there is not one in the whole archipelago more lovely than Enoshima, or the Island of the Bay. It rises out of the blue sea like an emerald, and whether viewed at the sunset hour, when the snow-white of Fuji Yama turns to gold, or with the purple hills of Hakoné in the background, or with the azure headlands of Idzu or Oshima in perspective, it is ever beautiful.

At every high tide, or when the wind blows from the sea, Enoshima is really an island surrounded by water; but usually a long strip of dry sand joins the island to the mainland. One must walk carefully, however, lest the waves with their tangled foam roll over his shoes.

The entrance to the rocky island is through a Tori-i, or temple portal, and up a steep street like a flight of stairs. On each side is a wonder-world of color and sheen in the museum of shells and sponges, coral and sea-fern. The "pencil coral" or spun glass, which looks as though some deep-sea silkworms had been spinning a hank of threads, or the glass-blowers had made a plume of spun glass, is here very plentiful. These, however, are only the legs of a once living animal, and they are not coral, but sponges. Here, also, are flowers made of tiny shells sewn together. Hotels and shops line the street, for hundreds of pilgrims visit this holy place every year, and each likes to buy and take home a souvenir of the wonderful island.

Around in the deep-sea waters of this island giant crabs, with bodies as big as a ham, and whose arms or outstretched claws are as long as a hay-rake, measuring ten or twelve feet, are sometimes captured. In the deep holes around the rocky shore, boys will dive into the depths for a few copper cash; and men, after first saying their prayers, will plunge many feet to the bottom and bring up the *awabi*, called also the haliotus, or sea-ear. There is a long, narrow cave on one side of the island, in which they say two white dragons once lived, and monster cuttle-fishes have their lairs in the cavern holes.

In the olden time, before the ancestors of the

Mikado descended from heaven, or the pine-tree of Takasago flourished, before there was an island in the Bay of Sagami, there were great marshes and ponds in this region in which five huge dragons lived. They were the kind that make food of human beings. They especially liked to devour children, because these were more tender to eat. No one dared approach the dragons' lair, and as for killing them, there was no man brave enough to attempt it. Things grew worse and worse. One poor father, whose tomb is pointed out in the temple graveyard of the village near by, lost sixteen children, one after another. There was not only the dreadful danger of being devoured, but when the dragons were hungry the heavens resounded with their growls and roaring. They often fought each other, leaving the reeds and rushes covered with blood, and the ground littered with scales or torn up with their claws, like the furrows left by a plough. So dreadful was the devastation caused that the village was named Koshigoyé, which those who tell this story say is derived from *ko* (child), *shi* (death), and *koyé* (passing over), because the inhabitants had to emigrate to other regions after their children had been killed.

At last the dragons disappeared. No more children were eaten up, and the marshes became fertile land, where the rice is planted every June and reaped every November. How did it happen?

In the sixth year of the reign of the Mikado Kaikua (157–98 B. C.) a great storm arose at night off the coast where the dragons' marshes lay. Black clouds covered the sea, and the waves mounted to heaven. In the morning, celestial music was heard, and through a rift an angelic lady accompanied by two youths of surpassing beauty was seen. She was arrayed in long white robes and flowing drapery. In her hands she held a three-stringed lute, which she played, striking the cords with an ivory stick. On her head was a crown of gold, set with rarest sea-shells and gems. Bracelets of gold clasped her wrists, and her slippers were of velvet, crusted with fine gold. The storm ceased, the black clouds wholly lifted and gradually rolled away. Then there appeared, in the ocean, Enoshima, or the island of the bay.

The heavenly lady was sitting not on a cloud, but on the top of the island, on a basalt rock, flower-strewn and mossy, which overhung the waves. When the great round sun rose out of the silvery mist in the eastern sea, the face of the lady was in the centre of the disk, yet she seemed to shine brighter than the heavenly circle itself.

Then the dragons left their lair, and the people were no more troubled, and the celestial lady was believed to be mistress and tamer of the dragons. Wherefore all the people honored her and called her Benten, or the Heavenly Lady.

Benten is the queen of the World Under the Sea, and she came up out of the Under-world, or Riu Gu, to keep her dragons in order, and to create the lovely island of Enoshima to comfort the people for their children devoured by the dragons. Without her knowledge, they had become unruly and cruel. To make amends for their devastation she gave to the earth and mankind the peerless island.

Many centuries afterward, Hojo Tokimasa came to Enoshima to ask Benten to grant prosperity to his descendants. He wrote his prayer in the form of a poem, and laid it before her shrine. After waiting three weeks for her appearance, she rose out of the sea and promised to grant what he asked. She warned him, however, that if they should be unjust rulers, their power should pass away in the seventh generation. This came to pass, for there were only seven regents at Kamakura after Tokimasa.

As she left him to go down into the Riu Gu, she showed her real body, which was not that of a woman, but partly, at least, that of a dragon. Hojo picked up from the ground three of the shining black scales which had been shed from her body, and arranged them in the form of a pyramid for a crest. This trefoil of dragon scales became the family mark of the Hojo, and was embroidered on their flags, banners, and coats, stamped on their swords and weapons, and flashed

in gold on their helmets. For one hundred and fourteen years the dragon scales of the Hojo were victorious in Japan, until Nitta, the great captain, destroyed them and burned Kamakura.

Benten is the sea-mother and the nurse of Japan, the inventor of the lute, the guide of the evening star, and the model to all good mothers because she protected children from the dragons so long ago. Sailors and fishermen especially honor her. Sometimes they see her in the beautiful moonlight nights of summer, sitting with her lute on her knees at the edge of the cliffs projecting over the waves, singing sweet songs to the melodious music of the lute. So lovely is the melody that the evening star is guided by it up to its place in the sky. By it she leads out the tides in ebb, and sends them back in flood, using also the two jewels of the flowing tides, which the king of the World Under the Sea gave to the young Mikado Ojin.

While Benten is queen of the Under-world, she is on earth a model mother and a diligent housekeeper. She has fifteen sons, all of whom she educated and trained to useful trades or callings. The first is a government officer, as his robe of office shows. The second is a learned scholar, who carries a writing-box, with ink-stick, ink-stone, brush-pen, and rolls of paper for writing. The third is a bronze-caster. The fourth is a money-changer, with his lever scales for weighing

coins. The fifth, a farmer, carries a bundle of sheaves. The sixth, a merchant, holds a grain measure in his hand. The seventh, a cake-maker, flourishes a flour-scoop. The eighth, a tailor, lugs a bundle of coats in his hand. The ninth, a silk-rearer, bears a tray of mulberry leaves for the silkworms to feed on. The tenth is a saké-brewer, with keg and dippers. The eleventh is a priest, with the three-pronged " diamond club," the emblem of his office, called a *sanko*. The twelfth is the doctor, with his *inro*, or pill-box. The thirteenth is the breeder of animals, with his horse and humped ox. The fourteenth is a man-ager of travel by land and water, who lets out boats or carts on hire. The fifteenth, or pet son, has no business. He is the " lion's cub," as the apple of the indulgent parent's eye is called.

This is the reason why Benten is the type and example to all good mothers, and the ideal of fertility and harmony. There are many golden images of her in which she sits on a rock over-looking the blue sea. In the crested waves, and partly wound round and over the rocks, is a dragon sporting about, and holding in his claws the crys-tal jewel of the flowing tide. He is bringing it to his mistress. Benten sits, many-armed and many-handed, holding in her left palm the ebb-tide jewel. In the other hands are a sceptre, bow and arrow, thunder and lightning, while over her head is an aureole of dazzling rainbow colors. Her

robes blaze with gold. How beautiful, queenly, and motherly she looks, this tamer of the dragons and mistress of the sea!

Benten has a dragon's nature, after all, and the image tells the story. Out of her head there comes coiling up a great human-headed serpent. Perhaps she will turn into a dragon and crawl away into the sea, as she did when Hojo watched her and picked up three scales for a crest. All that belongs to water is changeable. Liquid, solid, and gas, water, ice, snow, frost, vapor, hail, clouds, are all forms of the one unstable element, water. "Even fishes and birds turn into each other," say the Chinese sages, whom the Japanese people believe. Which is Benten and which the dragon, and whether a snake or a beautiful lady, they can scarcely tell. Her temples are nearly always found on islands. Her worshipers never like to kill a snake, for these reptiles are sacred to her. As the sea, with its commerce yielding wealth, its fish making food, and its pearls and gems expressing beauty, attracts the sailor, fisherman, and pearl merchant, so Benten, the dragon-goddess, draws to herself, as mistress of the sea, ten thousand worshipers who pray to her for beauty, power, and wealth.

CHAPTER XVIII.

AFTER Nitta Yoshisada and Ashikaga Takauji had destroyed Kamakura and restored the supreme authority of the Mikado, Japan had again one ruler, court, and capital in Kioto. For nearly three years, from 1333 to 1336, monarchy was the rule.

Unfortunately the spoils system had become so fixed in practice that the victors soon quarreled over the division of office and rewards. They fought among themselves, and even set up rival Mikados, thus dividing the imperial family. Then a civil war, lasting fifty-six years, broke out. Kusunoki committed hara-kiri; Nitta died in an ambuscade near Fukui in Echizen. Ashikaga Takauji was in 1338 appointed Shogun, and rebuilt Kamakura. Again duarchy became the political system.

In this war of the northern and southern dynasties, the imperial nominee of the Ashikagas was Hogen, and he and his successors formed the northern line; but the southern dynasty, headed by Go-Daigo, had possession of the three sacred regalia, — mirror, ball, and sword. As in so many

other matters analogous to European history, this era of rival Mikados, or Sons of Heaven, was nearly contemporaneous with that of the rival Popes or Vicars of God at Avignon and Rome.

Kioto, during most of this wretched civil war, lay in ashes, and large portions of the empire were given up to anarchy. Finally, in 1392, at the request of Ashikaga, the southern emperor came to Kioto, yielded up the three sacred emblems, and, after solemn religious ceremonies in a temple, the feud was healed.

The Ashikaga rule at Kamakura lasted from 1336 to 1574, and the number of Shoguns was fifteen. The whole period was one of unrest and local wars, in the form of clan fights and feuds of the daimios. Feudalism was greatly developed when the Ashikaga rulers made the military governorships hereditary. The daimios, or territorial nobles, often preyed upon each other, and the powers at Kamakura were not always able to restrain their violence.

This was also the age of castle-building and the development of the arts and trades, of war and of splendid spectacles and shows, of hawking and falconry, and of the power of the priesthood and the monasteries. Most of the great daimios of later fame laid the foundations of their power during this era. Novelists, street story-tellers, and dramatists usually locate the time and plot of their works in the Ashikaga period. Any Judas can

be buried in this potter's field, and the origin of anything unusually bad or disgraceful is usually ascribed to "the times of the Ashikaga."

In our own day, especially, the memory of the Ashikaga has been execrated for their bad treatment of the emperors. While Columbus was crossing the Atlantic, expecting to find Zipangu with its gold-roofed palaces, the estate of the emperors in Kioto was at its worst. Poor and wretched, dependent upon the bounty of the Kamakura rulers, while Kioto was the scene of frequent battles and conflagrations, their lot was pitiful. I have seen Japanese students weep as they read the story of their wrongs.

Still further did Yoshimitsŭ, the third of the Ashikaga line, and others after him, insult the national dignity. They sent embassies to China, and consented to receive from the Ming emperor the title of King of Japan. They also paid the Chinese emperor a tribute of a thousand ounces of gold. In this respect, they acted like the vassal nations subject or tributary to China, so that, to the Chinese, Japan seemed no longer an independent country.

Although this is the way the matter looks to some Chinese historians, it must not be forgotten that the Japanese, while not excusing the Ashikaga, call this money an indemnity for injuries done by Japanese pirates. Their feeling has always been like that of the Americans, —

" Millions for defence, but not one cent for tribute."

Many of the coast people of Kiushiu, having no one to curb them, turned pirates. One daimio family encouraged piracy, and grew rich by plucking the Coreans and Chinese. Ever adventurous and brave, the Japanese sailors swarmed along the coast of Asia from Tartary to Siam. Not content with robbing ships, they often landed, and sacked and burned villages, towns, and even cities. These " sea Japanese " caused such fear and trouble that, to this day, along the coast of southeastern China, the mothers frighten unruly children by the cry, " The Japanese are coming." The people in more than one country, during this era, used to pray the gods in their temples to deliver them from the ravages of the Japanese, just as the Europeans prayed to be delivered from the fury of the Northmen.

When, therefore, the Chinese envoys came to Kamakura to complain of these robbers, it is said that Ashikaga paid the gold as indemnity, and not as tribute.

Nevertheless, one can easily understand how the name of the Ashikaga is as detested in Japan as that of Benedict Arnold is in America. In the excitement of 1868, the rough fellows in Kioto, called *ronin*, went into certain temples where carved wooden statues of the Shoguns of this family stood in honor. They first cut off the heads

of the images, and then stuck them up on the pillory in the common execution-ground, where outlaws were beheaded, as if they were real heads of common criminals. They meant by this that they intended to serve all oppressors of the Mikado in the same manner.

In the midst of the worst national confusion and disorder ever known in Japan, the first Europeans arrived in that country. A Portuguese named Mindez Pinto, and his two companions, had taken passage in a Chinese pirate-junk. Driven away from China by a storm, they reached Tanégashima. Kindly treated by the people of the island, one of the Portuguese made the governor a present of his matchlock, and showed him how to fire it. When he brought down a duck flying beyond arrow-range, the people, who had never seen such a thing, were amazed. Country people still call a pistol "Tanégashima," just as our word "bayonet" is named after the place, Bayonne, in France, where it was first manufactured. The Japanese are quick to imitate anything they want, and Pinto says that, during the six months they stayed on the island, the skillful armorers there made six hundred guns. In 1556, when he revisited the country, firearms were quite common in many towns.

Mendez, on his return to Europe, wrote a book which was long considered a story of the same character as "Robinson Crusoe." He made so

many wonderful statements that seemed lying exaggerations that he was dubbed, by a pun on his name, the "Mendacious." Thus unwittingly he helped to introduce a word into modern speech, just as Mr. Boycott of Ireland has done. Nevertheless there was much truth in the narrative of Mendez Pinto's adventures, and firearms were used in most battles in Japan from this time forward.

After Mendez Pinto, who, instead of Columbus, was the first known European to reach Zipangu, came Portuguese merchants and missionaries. Francis Xavier, a great and good man, afterwards canonized as a saint, after visiting Satsuma and other provinces went to Kioto. He probably expected to see the gold-roofed palace of the Mikado about which Marco Polo had written. Instead of a brilliant city, he found a place little better than a camp, and soon after left the country and died on the coast of China. Others followed him from Portugal, and soon the friars, in shovel-hats and with crucifixes in their hands, were preaching all over the country. Their astonishing success roused the jealousy and wrath of the Buddhist priests, for in fifty years they gained probably two hundred thousand converts. Some of these were daimios, who sent embassies to the Pope. One Japanese ship crossed the Pacific Ocean to Mexico, and thence the envoys reached Spain and Italy. Japanese travelers in our day have discovered their ancestors' portraits and letters among the palaces

of Italian nobles in the city of Rome. Two mag-
nificent suits of armor now in the museum at
Madrid, which these young men presented to
Philip II., king of Spain, are probably the oldest,
as they are among the finest, specimens of Japan-
ese art and workmanship ever brought to Europe.

Nearly every year, relics of the Japanese in
Europe, and of the native Christians and Jesuit
missionaries in Japan, come to light. Mr. Ernest
Satow has told the story of the books printed at
the Jesuit mission press in Japan. In this year,
1892, one of the Mikado's envoys in Europe has
discovered in a church in Venice a large stone
tablet commemorating the visit, in 1585, of the
same young men who presented the armor in
Madrid.

Like all the other Shoguns, the Ashikaga
claimed descent from the Minamoto, their ances-
tors having settled in the eleventh century at Ashi-
kaga, a village in the province of Shimotsuké, now
containing about two thousand people. The clan
and dynasty were destined to be overthrown by
Nobunaga, a man of Taira blood.

When Yóritomo and the Genji were hunting
out the Heiké to put them to death, the widow of
one Sukémori fled with her son into Omi, hiding
in the village of Tsuda, where the head man of the
village married her. One day a Shinto priest
lodging at the house saw this bright boy, the
great-grandson of Kiyomori, and asked that he

might have him to educate for the priesthood. Mother and step-father agreed. He lived at Ota, in Echizen, near the city of Fukui. When he married, as Shinto priests do, he became the common ancestor of two great warriors of the sixteenth century. These were Shibata, whose tomb and relics I visited when living in Echizen, and Nobunaga, the persecutor of the Buddhists.

Nobunaga was trained to arms from 1542 to 1549 by his father, who was a soldier bent on acquiring lands and castles, like most of the barons or daimios of the time. After his father's death, he made himself master of six provinces in central Japan. Seizing Kioto, he built the splendid castle of Nijo, now used as the city hall. He took the side of Ashikaga Yoshiaki and had him made Shogun, but after six years quarreled with him, and in 1573 deposed him. This act put an end to the Ashikaga dynasty, after their rule of two hundred and thirty-eight years.

While the political genius of this line of rulers was not great, as the patrons of art the Ashikaga are remembered with gratitude. Two of the most superb edifices in Kioto are the Golden and the Silver Pavilions, which were built by them. Though much despoiled, they are still visited greatly by tourists. Gold and silver were lavishly used in the woodwork, and the most skillful artists were employed to decorate the walls and ceilings. By their patronage of literature and art, a new

era of painting, poetry, and original prose com-
position was ushered in during the fifteenth cen-
tury. Indeed, it may be said that the founders
of the great national art flourished in this period.
Meisho (1351-1427), a priest in Kioto, painted
the death of Shaka (Buddha) for the first time
in Japan. It still exists in a temple, measures
twenty-six by thirty-nine feet, and has been copied
hundreds of times. Other famous painters whose
works now command great prices were Josetsu,
Shiubun, the two Kanos, and Sesshiu. The in-
fluence of China and Persia on the native art is
very noticeable, but from this time forth the art
of Japan has more power and originality. Land-
scape, flowers, birds, and subjects drawn from
history and mythology are boldly treated. With-
out oil, or our fashion of framing in gilt wood,
Japanese paintings on panels, or wall-hangings
called *kakémono*, increase in value and interest
the more they are studied.

CHAPTER XIX.

THREE FAMOUS MEN.

LONG before the fall of the Ashikaga, Kama-kura, having been repeatedly burned and sacked, had ceased to be a place of any importance. Kioto was the only seat of general government. The office of Shogun now fell into abeyance. With his two generals, Hidéyoshi in the south and Iyéyasŭ in the east, Nobunaga soon had most of Japan under his control. His aim was to make the Mikado supreme, and to restore the imperial dignity. He never took the title or office of Shogun, which only men of Minamoto blood claimed; but as Nai Dai Jin, or Inner Great Minister, he ruled the empire in the Mikado's name.

Nobunaga handled the Buddhists roughly, for he considered that they were sometimes traitorous, and warlike, and he was himself at heart a fana-tical Shintoist. He patronized the Jesuit priests and granted them many favors. In the year 1582, when but forty-nine years old, in the height of his power, he was assassinated in Kioto by one of his traitorous captains named Akéchi. His tomb of granite stands in the keep, or highest

point, of his old castle of Adzuchi-Yama, overlooking Lake Biwa.

After Nobunaga, who was more of a soldier than a statesman, had "changed his world," Hidéyoshi, who was as able in government as in battle, took his place. Hidéyoshi is usually called Taiko. He rose to the highest rank a subject could hold, though he had once been only a stableboy. He became great through sheer merit. In his lifetime he had as many names as there are in a chapter of Chronicles. His mother called him "Bright Sun," others "Small Boy" and "Monkey Pine." Enlisting as a soldier, Nobunaga called him "The Man under a Tree." When a commander the people nicknamed him "Cotton," because he was good for as many uses as cotton. When he became a general he united the names of two of his lieutenants and called himself Ha-shiba. He made a banner out of a gourd, and every time he gained a victory he added a new gourd, until there were as many gourds as there are ribs to an umbrella. As the gourd-banner was never seen in retreat, but always in victory, the soldiers loved to follow it.

As soon as Hidéyoshi heard of the death of Nobunaga, he hurried to Kioto, and slew Akéchi, the assassin, and spoiled his ambitions. The proverb, " Akéchi ruled three days," is still applied to those clothed with brief authority who soon fall.

After a campaign in Echizen, in which Shibata was beaten and forced to commit hara-kiri, and his castle at Fukui was burned, Hidéyoshi returned to Kioto and began to develop the resources of the empire. He rebuilt the city magnificently, improved Fushimi, and made Nagasaki an imperial port.

Peace now smiled upon the country and its wealth increased, so that Hidéyoshi became very popular. He obtained from the Mikado the patent of a family name, Toyotomi. Not being able probably to tell who his grandfather, and possibly even his father, was, he gave out that his mother before his birth had dreamed that the sun had entered her body, and that he was conceived of this luminary. Such a dream was very common with Corean and Japanese mothers, and one often reads of such incidents in Oriental history. On account of this alleged dream he had taken the name of Hidéyoshi, which is composed of *Hi* (sun), *dé* (out of, or from), and *yoshi* (good), meaning " well conceived of the sun," or. " well born of the sun."

Hidéyoshi could not be Shogun, any more than Nobunaga, but in 1586 he obtained the office of Kuambaku, or Premier, which only nobles of Fujiwara blood had ever held. When, therefore, these proud high-capped and blue-blooded *kugé* saw the little wizen-faced man wearing the official head-dress and silken robes in an office known

only to their Heaven-descended ancestors, some
of them, behind his back, called him the "Saru
kuan ja," or the "Crowned Monkey." In 1591
he resigned this office in favor of his son, and be-
came Taiko (retired). Hence he is usually styled
Taiko Sama.

Probably no one subject of the emperor ever
had so much power as Hidéyoshi. He used it in
the name of the Mikado, but in reality he devel-
oped still further feudalism, which is always op-
posed to monarchy as well as to democracy. In
theory, all the land of Japan belongs to the empe-
ror. Feudalism divides up the land and gives it
to hundreds of vassals, who become obedient to
the chief military lord, while the people on the
land become tenants, and often little better than
slaves. Yoritomo first swallowed up the civil in
the military power by putting his own relations
and vassals over the various provinces. The Ashi-
kaga carried the system further by making the
military governorships hereditary, and thus the
lands governed were practically the property of
the soldier-lords who governed them. Hidéyoshi
boldly took the step of parceling out the whole
empire, and giving lands to daimios, without ever
asking the Mikado or consulting with the court.

Although the country was now at peace, yet
war had been the rule for generations, and there
were hundreds of thousands of soldiers who lived
by arms. How could they be employed? Taiko
patronized art, and invented the *cha no yu*, or

tea-ceremonies, by which they were amused for a
time, but they were not easily weaned from war.
Further, some of the leading generals were Chris-
tians, while their rivals were Buddhists. With
native and foreign priests hostile and jealous, and
the foreigners even suspected of designs against
Japan, how could the rivals be kept from quarrel-
ing? How could peace and a stable government
be maintained?

These were questions which Hidéyoshi began
to consider just when his own ambition made him
think of conquering Corea and even China. Was
not Corea properly subject to Japan, on account
of the former conquest of Jingu Kōgō? The
Coreans had not sent any tribute since early in
the century, and this Hidéyoshi used as a pretext
of invasion. So, in spite of embassies and nego-
tiations, two veteran armies were ordered to ad-
vance on the Corean capital, and a war lasting
from 1592 to 1597 began. At first the Japanese
were victorious. They captured the Corean capi-
tal and many stone-walled castles, and occupied
nearly the whole of the eight provinces. When,
however, the Chinese allies entered Corea with
vast armies, the Japanese were forced to retreat.
Bloody battles and long sieges, and the feeding of
two great armies, left Corea in a state of desola-
tion, from which she has hardly yet recovered.
Japan probably lost a hundred thousand men in
battle and disease by this war. The Japanese
name is still execrated in Corea.

In 1598 Taiko Sama died, and Corea was
evacuated. The armies brought back immense
treasures and spoils from the monasteries and
houses of the nobles. Thousands of Corean pris-
oners who remained in Japan, or skilled work-
men imported, introduced new arts and trades.
The celebrated Satsuma potters were Coreans.
In Kioto, beside many other reminders and relics,
the great ear-tomb, built in the *go-rin* or five-
tiered form on the top of a mound, covers several
thousand ears severed from Corean corpses as
ghastly tokens of Japanese victory.

The age of Taiko was one of great activity in
war, industry, art, literature, and navigation. It
deserves a history by itself. In many seas and
countries of the East, Japanese voyaged or made
settlements, and the traders, pirates, and settlers
carried afar the fame of the great Taiko. In
domestic politics, by following up the work of
Nobunaga, overcoming the feudal chieftains, hum-
bling Satsuma, Choshiu, and the other great clans,
Taiko prepared the way for Iyéyasŭ, and made
his work easy. Of this great man, Taiko's suc-
cessor, we shall now speak.

In the twelfth century, one of the younger sons
of Minamoto Yoshiiyé took the name of Toku-
gawa, and the family settled in the province of
Kodzuké. In the fourteenth century, driven out
in the wars of the Ashikaga, they took refuge at
the village of Matsudaira, in Mikawa.

One of the young sons adopted by the mayor of the village took this name, Matsudaira, which was formally assumed by his descendants, and has been so famous for the last three hundred years. It is said that the father of Iyéyasŭ, in 1529, when returning from a victorious expedition in Mikawa was entertained by his vassal Honda in his castle at Ina. During the feast, Honda presented his guest with some cakes served on a round wooden tray. The refreshments had been neatly laid on three asarum or wild-ginger leaves. Seeing these three leaves in a circle the successful warrior cried out, "I have received these leaves while returning victorious, therefore I shall adopt them as my crest."

This trefoil badge of three asarum or Japanese "hollyhock" leaves laid inside of a ring is seen on thousands of art-objects in gold, silver, lacquer, silk, or wood. For over two hundred years, on flags, banners, temples, baggage, and dresses, as the Tokugawa crest, it overshadowed even the imperial chrysanthemum.

Iyéyasŭ was born in 1542, and served under both Nobunaga and Hidéyoshi. He built a splendid castle at the city now called Shidzŭoka. He overcame the "second Hojo" family, who had a castle at Odawara. Since Kamakura had become a village of little importance, Iyéyasŭ chose another place, called Yedo ("Bay-door"), as the site of his future city.

Iyéyasŭ made peace with Corea and sent home many of the Corean prisoners. He then began to watch the movements of the warlike generals and southern daimios who had returned. They were flushed with victory, and wanted to have their own way. Many of them leagued themselves together as the retainers of Hidéyori, the son of Taiko. War soon broke out, and the army of the league and the eastern army of Iyéyasŭ met in battle at Sékigahara, or The Field of the Barrier, in October, 1600. Iyéyasŭ achieved a complete and decisive victory. Being now virtually ruler of all Japan, and the man for the work at hand, the Mikado and court, early in 1603, made him Séi-i Tai Shogun. Henceforward Yedo was to take the place of Kamakura.

Iyéyasŭ laid out the new city in grand outline, and gradually built it in splendid style. He also reconstructed the feudal map of Japan, dividing the country into nearly three hundred fiefs or principalities. He put his most faithful retainers near Yedo and Kioto, and so arranged friends, foes, and rivals, that none of his enemies could successfully combine against him, or seize Kioto or the Mikado. He gave audience to the Dutch and English merchants, encouraged foreign trade, revived the study of literature, collected books and manuscripts, developed the national resources, and cultivated the arts of peace.

He had but one campaign to fight, and that

was in 1615, when the castle of Osaka was be-
sieged, and the malcontents who had gathered
round Hidéyori were scattered. Iyéyasŭ died in
1616. His bones, after resting for a year at
Kŭno Zan, were borne in grand procession to
Nikko, the most beautiful place in Japan.

The successors of Iyéyasŭ, the Shoguns of the
Tokugawa dynasty, carried out the founder's ideas,
and for two hundred and fifty years, with the ex-
ception of the successful campaign at Shimabara
in 1637, against the Christians who had risen in
rebellion, the land had perfect peace.

In this long interval of peace, the feudal system
was perfected. The *kugé*, or court nobles, in
Kioto, sprung from gods and Mikados, and in-
tensely proud of their blue blood and immemorial
lineage, lived quietly in the enjoyment of flowers,
poetry, and etiquette. In one sense, Kioto was
the sacred city ; the *kugé* formed a college of car-
dinals; and the Mikado was an infallible Pope.
Between 1612 and 1866, fourteen occupants of
the throne, two empresses and twelve emperors,
reigned, but none was of any personal importance,
or, so far as known, influenced history.

Of the daimios, or nobles who possessed land
and ruled their provinces or dominions as heads
of clans, eighteen were Koku-shiu (rulers of prov-
inces) whose capitals were large cities, and whose
revenues amounted to millions of dollars. Most
of these daimios of the first rank traced their de-

scent to the military governors appointed by Yo-
ritomo. Those of Kaga, Satsuma, Sendai, Echi-
zen, Higo, Choshiu, and Hizen were among the
best known, and some were relatives of Iyéyasŭ.
This was the case with the lord of Echizen, in
whose dominions, at the capital city of Fukui, the
writer spent the year 1871. Two daimios, Sataké
and Nambu, claimed to be descendants of Ojin, the
god of war.

After the eighteen great daimios who ruled
provinces, came those called Kamon, also eighteen
in number. These were relatives of the Toku-
gawa family, and took the name Matsudaira. The
Tozama, or outside lords, that is, not relatives of
the Tokugawa, numbered nearly one hundred. Of
the Fudai, or successive families, who were de-
scendants of the vassals of Iyéyasŭ, there were
four clans or families distinguished by the term
Kin-shin, or relatives, from whom the regent was
chosen when the Shogun was a minor. Eighteen
other clans were called the Old Fudai, and held
in special honor, because their ancestors served
Iyéyasŭ before he was the Shogun of all Japan.
The head of the Fudai daimios was Ii Kamon no
Kami, lord of Hikoné, on Lake Biwa, and in a
sense the guardian of Kioto.

In addition to·all these powerful vassals, the
Shogun had an army of eighty thousand soldiers,
called *hata-moto*, or flag-supporters, at his beck
and call. Iyéyasŭ prohibited the western daimios

from entering Kioto, and made many other severe restrictions. Iyémitsŭ, the third Shogun of the Tokugawa line, began the custom of having all the daimios spend half the year, or every other year, in Yedo, leaving their wives and children as hostages when in their own domains.

Gradually, the Yedo government grew more oppressive, and often purposely kept certain daimios poor by enforced gifts or expensive public works. The processions of these feudal lords to and from, and while in Yedo, were usually very imposing. In the case of the Koku-shiu, they numbered a thousand men or more, — the display of horses, furniture, equipage, decorative spears, umbrellas, banners, and all sorts of feudal insignia, making a gay parade. These constant movements made the high roads very lively, and gave to the people of the villages through which they passed a spectacular treat. They also furnished the hotels with business, and kept Yedo and the large cities full of gay shops. When a train passed by, all horsemen must dismount, the common people kneel down, and every one remove his head-covering. To refuse to obey these rules was an insult to the daimio, and might result to the offender in a beating or death. When foreigners came to live in Japan, some of them lost their lives from not knowing these customs.

Government existed mainly for the benefit of the Samurai; and the other classes, especially the

traders, had few rights which the sword-wearers were bound to respect, while the beggars and Eta or *hi-nin,* two of the very lowest of the many grades of humanity in feudal Japan, had no rights whatever.

In passing over the details of history during the Tokugawa period from 1603 to 1868, except to say that fifteen Shoguns ruled, seven of the direct line of Iyéyasŭ, seven of the house of Kii, and one of the house of Mito, we shall glance at the life of the people as reflected in their art-symbols, folk-lore, and household superstitions, and then note the forces which shattered the system of Iyéyasŭ and produced New Japan.

CHAPTER XX.

IDEAS AND SYMBOLS.

WHEN we take a walk in Japan, we notice that the landscape and nearly everything in it are different from what we should see at home in America or Europe. In our American Northern States the landscape has been formed by the glacier. In Japan, the volcano and earthquake have been the chief shaping forces. Many of the trees and flowers are similar to ours, and Dr. Asa Gray has shown that there is a wonderful likeness between the Japanese and American flora. Yet, on the other hand, the camphor, camellia, and cryptomeria trees, the groves of bamboo, and the many varieties of lilies, azaleas, and asters show great differences, or remind us that we have borrowed many things in our gardens from the land of camellias. We should notice that both tropical and arctic plants abound, as though the Japanese archipelago were a meeting-place of many currents from many climes.

But what would remind us more than anything else that we were in a strange country would be the bright-red pagodas peeping out among the evergreen trees, and the wayside shrines of idols

at the cross-roads and under the brows of the hills.
The curious gateways of stone or wood, called the
tori-i, or "bird-rests," leading to little temples
hidden away in the shrubbery, would often strike
the eye. Frequently we should see the pathway
shadowed by a score or more of these curious
wicket-like structures.

If we went into a cemetery, beautiful though it
might be with trees and shrubs, we should notice
at once a different sort of tombs. The absence
of the symbols of hope and of the resurrection
would be at once noticeable. In place of these,
we should find square columns well incised with
Chinese characters. Near new graves, or jars of
fresh ashes, we should find flat boards covered with
Sanscrit symbols. Though so far away from India,
this Sanscrit writing, and the ringed and banded
masses of stone that look like miniature pagodas,
are very common. Imposing five-tiered monuments
rise over the dust or ashes of the rich or famous.
These are made of a cube, a sphere, a pyramid,
a crescent and a flame-shaped stone. The in-
scriptions, could we read them, would be found in
some respects very different from ours, though
in others much the same. Fresh flowers set
before the tombs would prove that many hearts
still remembered the dead.

Walking along the streets of town or city, we
should see no gilded weathercocks, domes, or
spires with flashing cross. The house corners

and ends of public buildings, on which men like
to put ornaments that mean something, would
show figures very different from ours. Yet all
would be interesting and full of meaning. It
would show us that their world of ideas, their
history of the past, their education and discipline
of mind, their material for dreams and fairy tales,
and poetry and art, grew up where ours did not.
To travel in Japan is, in one sense, like visiting
the moon, supposing, as the Japanese fairy tales
do, that the moon is inhabited.

In Christendom, law, society, customs, art, and
even language are much alike. But in the Chi-
nese world, and in Buddhadom, the thoughts and
the manner of expressing thoughts in books,
pictures, statuary, architecture, all kinds of art,
and even in the garden and the burying-ground,
are very different.

The Japanese do not like things square, or
balanced, or symmetrical, either in decoration or
in landscape. A Japanese gardener, in preparing
a bit of ground in order to make a park or gar-
den, does not follow our stiff and regular methods.
In subduing wild nature into more perfect beauty
he does not destroy; he only trains and educates.
Whether his garden be in a little box a foot
square, or in a park of many acres, he will have
a landscape like that which nature has made.
There must be hills, valleys, a waterfall, a stream-
let, a lake, with trees, bushes, shrubs, grass, and

flowers. This is nature's part. Then there must
be paths, stepping-stones, lanterns, seats, hedges,
bridges, gateways, a well, guide and notice boards,
a little cottage or pavilion, a moon-viewing cham-
ber, or tower of observation; with perhaps a pail
of cakes for feeding the goldfish, and a pebbled
strand or jetty to stand on. This is man's part.

All this, when complete, will be a perfect mar-
riage of nature and art, charming to the eye and
harmonious with the sense of beauty. Still further,
it will awaken thought, and be as enjoyable as
music or poetry. It will please the mind as well
as the eye. To the cultivated person, each step-
ping stone, path, hillock, ornament in bronze, wood,
or stone, will have a meaning, and will call up to
the imagination some pleasant association as surely
as the key-note suggests a tune, or our words,
" Mid pleasures and palaces," call to mind the
tender sentiment and music of " Home, Sweet
Home," or an orange blossom tells of a bride and
wedding, or a cradle compels one to think of a
baby.

In the cemetery each letter, shape, and figure
has a meaning. Near newly-made graves, or the
hollow tombs which contain the fresh ashes from
the cremation house, staves of wood stand upright.
On these are inscribed the Sanscrit *bongo* or
priest's letters. The particular letter oftenest
used is a symbol of the human frame, summing up
in its meaning head, arms, breast, body, and legs.

Near the temple will usually be seen a pagoda, which is a many-storied, tall column of handsomely carved wood, painted vermilion. The number of stories, five, seven, nine, or eleven, must be an odd one. Originally it was an act of merit to place such structures over the graves of departed friends. The first were built in India, usually over the relic of some Buddhist saint. In China the pagoda is called by a name meaning "the white bone tower," but in Japanese the word *to* means only a column. The roofs and edges of the stories or platforms are curved upwards, like the roofs of temples and *tori-i*. Little brass wind-bells, which clink and rattle in every breeze, are hung on the corners of many houses and high places, and make an odd kind of music whenever a breath of air is stirring. One of Bakin's prettiest stories is called "The Golden Wind-Bell of Kamakura."

Certain curious fossils found in limestone, when cut open, look like pagodas, and the common folks believe these are caused by the pagoda shadows falling on the earth. The tops of these wooden towers, which in Japan are almost always square, are surmounted by copper spindles full of rings, as many as there are stories in the pagoda. The tip of the spire thus looks like the plume or pompon of a helmet. Often on the top of this corkscrew-looking affair is a vane-like sheet of copper, cut along the edges to resemble a flame of fire; and,

surmounting the whole, is the *tama*, or jewel which symbolizes the soul. In time of a severe earthquake, this pagoda spire sways and rocks like a pendulum turned upside down; but the pagodas are well built, and are rarely or never overthrown. Indeed, some of these square towers are hollow like a bell, and have a great pendulum or tongue of heavy wood inside hanging throughout their whole length. This helps the tall mass to keep the centre of gravity during the rocking of the earth.

This *tama*, or jewel, also called the "sacred pearl," is an emblem of the soul, and in Japanese the word for "soul" and "jewel" is the same. It is properly a crystal ball, or pear-shaped gem, grooved or ringed at the top near the stem. On Japanese pictures, trays, cabinets, and bronzes we may see it held in the dragon's claw, or the dragons are fighting for it, or it is wreathed in fire, or it is set in places of honor, or the Dragon King of the World Under the Sea presents a pair to Ojin, the baby Mikado who goes to conquer Corea. It is the jewel of the ebbing and the flowing tide, controlling the movements even of the ocean. Indeed, the sacred jewel, in some form, plays a wonderful part in Japanese mythology, fairy tales and art. One of the prettiest stories in which it figures is that of Tan Kai Ko. A fisher-maid is beloved by a court noble, and for his sake dives down beneath the sparkling

waves into Riu Gu, and, defying the dragons, seizes the holy jewel and brings it up to earth. The Japanese are very fond of rock-crystal balls, and the lapidists carve them so skillfully from the flawless quartz that, when resting on a tripod of silver, each seems like a floating bubble.

What is the origin of the idea, and how was the symbol evolved?

The Buddhists believe that when the body of a saint or holy person is cremated, there will be found in the ashes a hard, shining substance like a gem. It is called a *shari*, and it used to be eagerly looked for in the ashes of the cremation furnace. This, when found, was usually smaller than a pea. It was then carefully inclosed in a little shrine or box shaped like a pagoda. This "pocket god-house" was made of rock-crystal, and the *shari*, or soul-substance, was easily visible through the transparent stone. I have several times seen these pocket pagodas containing one, two, or three *shari* in the compartments or stories of the little upright cases, which are from two to five inches high. They are the equivalents and visible manifestation of the souls of the departed. Of course it was not difficult to find *shari*, where there were so many priests ready to assist the credulous. A thousand years ago, these little soul-caskets were made in the form of a tomb, that is, in five parts, which we shall describe below. Little models of the actual tombs built in the cemeteries

were also made in clay, about three inches high, and kept in houses or temples. The top of each miniature tomb or pagoda was fashioned like the pear-shaped *tama*, or emblem of the soul.

Now, if we go out into a burial-ground, we shall see, over the graves or ashes of rich or saintly people, the *go-rin*, or five-blossom tomb. It consists of a cube, sphere, cone, crescent, and flame-shaped stone. The cubic square represents earth; the water-drop or ball, water; the pyramid, flame or fire; the saucer or crescent, wind or air; and the top, which takes the form of a flame just going out, represents the *tama*, soul or jewel. In other words, here are the five elements out of which man is made, and to which he returns after death — earth, water, fire, air, and ether. Though the emblem of the spirit is usually spherical, yet very often, again, it is pear-shaped or grooved near the top. Hence it is probable that the ringed and pear-shaped jewel is only a conventional and condensed form of the *go-rin*, or the five elemental essences.

In modern times, also, by gradual evolution, the *go-rin* tomb has become the graceful *to-ro*, or stone garden-lantern, and the superb bronze lamp-holder, taller than a man. Hundreds of these, as memorial offerings of the vassal princes to the Tycoons, are found in the outer courts of the cemeteries in Tokio and Nikko. When, at night, the numberless lamps in these prettily sculptured

light-bearers are lighted, and twinkle through the
trees, the effect is like that of fairyland. In many
of these, in front of temples, the lamp burns from
sunset to sunrise. On one, I remember reading
the inscription, "To give light during the long,
dark night."

The custom of the military vassal's bringing a
gift when he visited his lord is a very old one in
Japan. Iyéyasŭ and his successors reduced it to
a system. In Yedo, the two large parks, Uyéno
and Shiba, were set apart to be the burial-grounds
of the Shoguns, and were made to excel even
Nikko in splendor. All that art and wealth could
devise were lavished in the adornment of the
groves, gardens, gates, courts, temples, and tombs.
At these places one can study the wonderful rich-
ness of Japanese memorial and decorative art.
Very noticeable, in the pebbled outer courtyards
of Shiba, are the hundreds of high stone lanterns,
arranged row upon row like the ranks of an army,
the gifts of the Fudai daimios. In the next court
stand the superb bronzes; and nearest the shrine
stands a trio of colossal lanterns covered with
gold, the gift of the San-ké, or three princely
families, Mito, Kii, and Owari.

CHAPTER XXI.

THE ASHES THAT MADE TREES BLOOM.

THE specimen of Japanese folk-lore here given illustrates life among the common people during the Tokugawa times, and their Buddhistic beliefs. We tell it in the same style in which it is usually narrated in Japan.

In the good old days of the daimios, there lived an old couple whose only pet was a little dog. Having no children, they loved it as though it were a baby. The old dame made it a cushion of blue crape, and at meal-time Muko — for that was its name — would sit on it as demure as any cat. The kind people fed the pet with tidbits of fish from their own chopsticks, and it was allowed to have all the boiled rice it wanted. Whenever the old woman took the animal out with her on holidays, she put a bright-red silk crape ribbon around its neck. Thus treated, the dumb creature loved its protectors like a being with a soul.

Now the old man, being a rice-farmer, went daily with hoe or spade into the fields, working hard from the first croak of the raven until O Tento Sama (as the sun is called) had gone down behind the hills. Every day the dog followed

him to work, and kept near by, never once harming the white heron that walked in the footsteps of the old man to pick up the worms. For the old fellow was kind to everything that had life, and often turned up a sod on purpose to give food to the sacred birds.

One day doggy came running to him, putting his paws against his straw leggings, and motioning with his head to some spot behind. The old man at first thought his pet was only playing, and did not mind it. But the dog kept on whining and running to and fro for some minutes. Then the old man followed the dog a few yards to a place where the animal began a lively scratching. Thinking it only a buried bone or bit of fish, but wishing to humor his pet, the old man struck his iron-shod hoe in the earth, when, lo! a pile of gold gleamed before him.

He rubbed his old eyes, stooped down to look, and there was at least a half peck of *kobans*, or oval gold coins. He gathered them up and hied home at once.

Thus, in an hour, the old couple were made rich. The good souls bought a piece of land, made a feast to their friends, and gave plentifully to their poor neighbors. As for doggy, they petted him till they nearly smothered him with kindness.

Now in the same village there lived a wicked old man and his wife, who had always kicked and scolded all dogs whenever any passed their house.

Hearing of their neighbors' good luck, they coaxed the dog into their garden and set before him bits of fish and other dainties, hoping he would find treasure for them. But the dog, being afraid of the cruel pair, would neither eat nor move.

Then they dragged him out of doors, taking a spade and hoe with them. No sooner had doggy got near a pine-tree growing in the garden than he began to paw and scratch the ground, as if a mighty treasure lay beneath.

"Quick, wife, hand me the spade and hoe!" cried the greedy old fool, as he danced with joy.

Then the covetous old fellow, with a spade, and the old crone, with a hoe, began to dig; but there was nothing but a dead kitten, the smell of which made them drop their tools and shut their noses. Furious at the dog, the old man kicked and beat him to death, and the old woman finished the work by nearly chopping off his head with the sharp hoe. They then flung him into the hole, and stamped down the earth over his carcase.

The owner of the dog heard of the death of his pet, and, mourning for him as if it had been his own child, went at night under the pine-tree. He set up some bamboo tubes in the ground, such as are used before tombs, in which he put fresh camellia flowers. Then he laid a cup of water and a tray of food on the grave, and burned several costly sticks of incense. He mourned a great while over his pet, calling him many dear names, as if he were alive.

That night the spirit of the dog appeared to him in a dream and said : —

"Cut down the pine-tree which is over my grave, and make from it a mortar for your rice pastry, and a mill for your bean sauce."

So the old man chopped down the tree, and cut out of the middle of the trunk a section about two feet long. With great labor, partly by fire, partly by the chisel, he scraped out a hollow place as big as a half-bushel. He then made a great, long-handled hammer of wood, such as is used for pounding rice. When New Year's time drew near, he wished to make some rice pastry. So the white rice in the basket, and the fire and pot to boil the rice dumplings, and the pretty red lacquered boxes, were got ready. The old man knotted his blue kerchief round his head, the old lady tucked up her sleeves, and all was ready for cake-making.

When the rice was all boiled, granny put it in the mortar, and the old man lifted his hammer to pound the mass into dough, and the blows fell heavy and fast till the pastry was all ready for baking. Suddenly the whole mass turned into a heap of gold coins. When, too, the old woman took the hand-mill, and, filling it with bean sauce, began to grind, the gold dropped like rain.

Meanwhile the envious neighbor peeped in at the window when the boiled beans were being ground.

" Goody me ! " cried the old hag, as she saw each dripping of sauce turning into yellow gold, until in a few minutes the tub under the mill was full of a shining mass of *kobans* (oval gold-pieces), " I 'll borrow that mill, I will."

So the old couple were rich again. The next day the stingy and wicked neighbor, having boiled a mess of beans, came and borrowed the mortar and magic mill. They filled one with boiled rice, and the other with beans. Then the old man began to pound and the woman to grind. But at the first blow and turn, the pastry and sauce turned into a foul mass of worms. Still more angry at this, they chopped the mill into pieces, to use as firewood.

Not long after that, the good old man dreamed again, and the spirit of the dog spoke to him, telling him how the wicked people had burned the mill made from the pine-tree.

" Take the ashes of the mill, sprinkle them on withered trees, and they will bloom again," said the dog-spirit.

The old man awoke, and went at once to his wicked neighbor's house, where he found the miserable old pair sitting at the edge of their square fireplace, in the middle of the floor, smoking and spinning. From time to time they warmed their hands and feet with the blaze from some bits of the mill, while behind them lay a pile of the broken pieces.

The good old man humbly begged the ashes, and though the covetous couple turned up their noses at him, and scolded him as if he were a thief, they let him fill his basket with the ashes.

On coming home, the old man took his wife into the garden. It being winter, their favorite cherry-tree was bare. He sprinkled a pinch of ashes on it, and, lo! it sprouted blossoms until it became a cloud of pink blooms which perfumed the air. The news of this filled the village, and every one ran out to see the wonder.

The covetous couple also heard the story, and, gathering up the remaining ashes of the mill, kept them to make withered trees blossom.

The kind old man, hearing that his lord the daimio was to pass along the high road near the village, set out to see him, taking his basket of ashes. As the train approached, he climbed up into an old withered cherry-tree that stood by the wayside.

Now, in the days of the daimios, it was the custom, when their lord passed by, for all the loyal people to shut up their second-story windows. They even pasted them fast with a slip of paper, so as not to commit the impertinence of looking down on his lordship. All the people along the road would fall upon their hands and knees, and remain prostrate until the procession passed by. Hence it seemed very impolite, at first, for the old man to climb the tree and be higher than his master's head.

The train drew near, with all its pomp of gay banners, covered spears, state umbrellas, and princely crests. One tall man marched ahead, crying out to the people by the way, "Get down on your knees! Get down on your knees!" And every one kneeled down while the procession was passing.

Suddenly the leader of the van caught sight of the aged man up in the tree. He was about to call out to him in an angry tone, but, seeing he was such an old fellow, he pretended not to notice him and passed him by. So, when the daimio's palanquin drew near, the old man, taking a pinch of ashes from his basket, scattered it over the tree. In a moment it burst into blossom.

The delighted daimio ordered the train to be stopped, and got out to see the wonder. Calling the old man to him, he thanked him, and ordered presents of silk robes, sponge-cake, fans, a *nétsŭké* (ivory carving), and other rewards to be given him. He even invited him to visit him in his castle.

So the old man went gleefully home to share his joy with his dear old wife.

But when the greedy neighbor heard of it, he took some of the magic ashes and went out on the highway. There he waited until a daimio's train come along, and, instead of kneeling down like the crowd, he climbed a withered cherry-tree.

When the daimio himself was almost directly

under him, he threw a handful of ashes over the tree, which did not change a particle. The wind blew the fine dust in the noses and eyes of the daimio and his Samurai. Such a sneezing and choking! It spoiled all the pomp and dignity of the procession. The man whose business it was to cry, "Get down on your knees," seized the old fool by the top-knot, dragged him from the tree, and tumbled him and his ash-basket into the ditch by the road. Then, beating him soundly, he left him for dead.

Thus the wicked old man died in the mud, but the kind friend of the dog dwelt in peace and plenty, and both he and his wife lived to a green old age.

CHAPTER XXII.

Now that the Japanése are being civilized after the Western fashion, a great many of the old beliefs of the people are passing away. Men of science, the doctors, and the boys and girls taught in the public schools laugh at the ideas of their grandmothers. In the cities and towns the old folk-lore and fireside stories are being forgotten, and the household customs and superstitions are fading away. In the country they linger longer, and millions of Japanese still believe that cutting the finger nails too closely weakens the strength, that drinking milk produces skin diseases, or that washing the head on " the day of the horse " will make their hair red.

The doctors are busy in showing the Japanese that the laws of good health demand that they give up wearing straw sandals and wooden clogs, and put on leather boots and shoes. They tell them to furnish their houses with chairs and tables, and that plenty of soap skillfully applied, and frequent changes of under-clothing, are good for them. But the country folks are very apt to do as their fathers did. Their houses are built under

the spell of superstitious ideas, rather than for comfort or health. But as in Europe and America, in spite of science, some people think there are dismal forebodings in a raven's croak and luck in a horseshoe, that it is not well to sit at dinner with thirteen people or begin a journey on Friday; so in Japan fears and hopes are awakened by certain signs and omens. Let us look at a few of these.

I have known Samurai gentlemen, who were fathers and wished their sons and daughters to go up in the world, who looked well to their gardens. They would never have a grapevine growing near their houses, because the fruit hangs downward. The words *nari sagaru*, to hang down, to descend from a high station in life to a low one, to become poor, would be sometimes spoken. It might mean that the boys and girls would also sink in the world. Such words of evil omen are avoided, and whatever might suggest them is removed from sight.

Some of these household superstitions bear a striking resemblance to, or are exactly like, our ideas on the same subject. Thus, the appearance of white spots on the finger-nails indicates to the possessor that she is to receive a gift. The more numerous the spots, the more dresses and presents she will receive. Young ladies especially believe this.

When a person's left ear itches, some one is

talking evil of him; if his right ear, good. When both ears need scratching, people are talking variously.

The croaking of the crow is a harbinger either of sorrow or gladness. Usually it is the former; but when the crow croaks with his throat towards a house in "jumping notes," the master will often cry out, " *Ukéta, ukéta* " (I accept it), and expect some accidental good fortune to befall him. When many crows assemble near a house and caw, it is a sign of misfortune to that house. Strange to say, lovers hear in the notes of the crow the tones of love and affection.

It is very easy to make puns in Japanese, and a great many times the pun is shown to the eye by an orange, walnut, radish, charcoal, or some other object, as well as by a word to the ear. A person about to start on a journey is often presented with a package containing a walnut (*kurumi: kuru*, come back, *mi*, man, — "May you return safely"), peas (*mamé*, healthy, active, busy), and a piece of dried fish, which expresses the hope that he may be well preserved while away.

If a person meet a funeral cortége in the street, it is a fortunate omen; but if, in walking along, the procession overtakes him, it is extremely un-fortunate. In such a case, the person overtaken will rush ahead into a house or shop to be out of sight. In passing a house in which there is a

corpse, many people put their thumb inside their fist to keep off the evil.

A child will die within the next three years if he be struck with a broom, beckoned to with a dipper, or if he fall down in a graveyard. A child is taught to eat carefully, and to handle the chopsticks deftly, by being warned that it will become a cow if it drop the rice on its clothes.

When people suffer from chronic ague, if a mirror can be put under the bed of the patient, without his knowing it, he will recover. In some other diseases, the calcined leg-bone of a man, taken from the cremation house, put under his head in the same way, will effect the same result. A Samurai often put the sword of the sick man in the same place for the same purpose.

Many daimios and their high officials formerly would not eat a roast herring (*konoshiro : kono*, also this, *shiro*, castle) because they were afraid their castle would be burned or destroyed.

A persevering lover, who would but cannot win his obdurate charmer, will succeed in melting her heart and making her love him, if he scatter upon her, unknown to her, some ashes of a water-lizard previously calcined and pulverized.

In pouring out oil for the lamp during *kan* (the coldest part of winter, late January or early February), if by accident even a single drop of oil is spilled on the floor, some damage will be done by fire to the house. This, however, may be

averted by sprinkling a few drops of water on the
head of the spiller of oil. I have known plenty
of amusement at the observance of this ceremony.
As in many other instances, the old superstition
has decayed into fun, and the merry laughing re-
minded me of an old plum-tree stump buried in a
mass of pink blossoms.

A shooting or " creeping " star denotes that a
soul has left the body. Some one is dead.

When a person sneezes once, some one is prais-
ing him; when two nasal explosions occur, he is
being decried; if he cachinnates three times suc-
cessively, he has taken, or will take cold. The
Japanese who has taken cold says: " Kaze wo
hiita " (I have drawn wind).

When the sun is seen to shine on falling rain,
instead of announcing that " the devil is beating
his wife," the Japanese people say that foxes are
marrying. The artists always represent the foxes
going to a wedding in a shower.

A comet portends earthquake, famine, typhoon,
war, or some other great calamity.

A Japanese boy who sees a sparrow walking
by putting one foot before the other, like a duck,
instead of leaping with both feet, is as happy as
the Irish boy who discovers a four-leaf clover for
the first time.

It is supposed that in a thunder-storm it is
perfectly safe to take refuge at the side of a
mulberry-tree, which in Japan is kept at a height

rarely over six feet, as the lightning never strikes the mulberry-tree.

When a swarm of bees alight near a house and make their honey, it is a sign of great prosperity coming to that house.

If a man find a fan lying in the road, he is likely to be a member of some noble family in the future.

On New Year's Day, merchants shut the doors of their storehouses, lest good fortune depart. People never sweep the floor on that day, lest good luck be also swept away.

A man who borrows money and gives his promissory note affixes his stamp upon the paper several times, always making an odd number. If stamped with an even number the note is not likely to be paid. In Japan a seal is even more important than a signature, and the government requires voters to stamp their ballots, and thus to reinforce their sign manual.

If, while dressing the hair, either masculine queue or feminine coiffure, the hairstring be broken, the omen is a sinister one. A wife may lose her husband, or a man his best friends.

It is a very bad custom to stick chop-sticks upright in a bowl of rice, for this is done for the dead.

By looking intently in a mirror at the hour of two in the morning, one may see the future of her life. A lady once tried to prove this assertion,

and, looking in the mirror, saw the figure of a beggar having her own countenance. After that she paid great attention to economy, and lived happily and in comfort all her life; but at her death, a mat such as beggars wrap themselves in fell down on the roof of her house, which proved that she had become a beggar in the other world!

The *udogé* is the name given to a very delicate flower which in rare instances blooms on a slender stem growing out of the ceiling or walls of a room, perhaps generated by the warmth and moisture. Its appearance is hailed with passionate delight by all natives of Japan, from noble to peasant's child. To the official, it is a harbinger of promotion; to the merchant, wealth; to the farmer, bounteous crops; to the student, success in acquiring knowledge.

The etiquette of the table requires that the chopsticks should be laid at the right of the eater. A gentleman or ordinary person, on sitting down to a meal and discovering that his chopsticks are laid on his left, will be very angry, and perhaps refuse to eat; for criminals also have their meals thus served.

A person does not like to receive any present which has no *noshi* upon it, because this is omitted in presents made to or for the dead. A *noshi* is a piece of gay-colored paper folded in a particular way, and always accompanying presents.

Three persons will never sweep a room together,

lest they see a spectre at night. The same num-
ber will never hang up a mosquito-net together
for the same reason. Mosquito-nets are called
ka-cho (mosquito-houses), and are of the same
size as the whole room.

Whenever the master of the house, or father of
a family, starts on a journey, it is quite common
to prepare his meals at home as usual while he is
away. This is done in order, as is supposed, to
propitiate his shadow, and avoid all risks of hun-
ger while away from home. Photography at first
was very unpopular, because it was supposed that
every time a person had his picture taken he lost
a certain portion of his soul, which went through
the camera into the photograph.

When a mother has died leaving a young infant,
the clothes of the new-born orphan, that may have
hung in the air during the day, are carefully
taken into the house at night. The reason for
this is, that the spirit of the dead mother comes
in the form of a bird, and, hovering near the gar-
ments of her child, makes it long for her and
causes it to cry.

Curious superstitions about the dog, the cat, the
fox, and the badger taking human shape, or en-
tering into men and women so as to possess their
souls, have for many centuries been current, and
the wonderful stories about them would fill a
library. Public schools, telegraphs, and railroads
are rapidly driving these creations of diseased

brains into oblivion ; yet the newspapers show that such phantoms of the imagination die hard. The foxes, that used to turn into daimios and lead processions, now become locomotives and railway trains. It will be a good many years yet before the last fox story is told in Japan.

CHAPTER XXIII.

THE DUTCH YEAST IN THE JAPANESE CAKE.

IYÉYASŬ and his line of Shoguns made it their business to build a sort of Chinese wall around Japan. More exactly, they trusted that, like a castle with a great ditch or moat filled with water all around it, Japan, with the ocean on all sides, could defy the enemy of change. Their policy was the double one of shutting out the foreigners and shutting in the natives. All ships larger than a certain size were burned. No Japanese must leave the country on pain of death. No ship-wrecked natives were to be returned by foreigners. On every high road, in the village and on the city streets, were hung the edicts prohibiting Christianity. Thus the rulers expected to keep out all disturbing forces. Whatever was like seed or leaven must be destroyed. Japan was to be in-vulnerable. It was to be a baptism of Achilles in the Styx on a national scale.

Yet all history shows that some little detail is omitted even in the best-laid plans of men. Achilles' heel is vulnerable; and a leaf falls on the back of Siegfried when he is dipped in the pool of dragon's blood. Both heroes lose their

lives through the weak spot. So with the Japanese. They are a people always full of curiosity. The Yedo rulers wanted to know what was going on elsewhere in the world. They therefore kept a peep-hole to spy out what other folks were doing.

Like rulers, like people. Many a time, while traveling in the country, I found at the hotel that the white stranger was looked at through the paper sliding partitions. In the other rooms, with stealthy footsteps, the women, and often the males, would, with finger moistened in the mouth, noiselessly punch a hole in the mulberry paper. Chancing to look up, I could see a flashing black eye at each hole.

After all, it was only a paper wall the Japanese were able to build. They punctured it at Nagasaki. Here, at Déshima, or the Outward Island, they allowed the Dutch to settle and build a factory, as a trading-house was then called. During twelve months, the Hollanders gathered up Japanese products and merchandise to exchange for European goods. Once a year the ships from Rotterdam or Amsterdam came to bring news and products.

The Dutch traders lived at Déshima under very strict rules, like the old German Hanse merchants in mediæval London. The Yedo rulers thought no harm could come from keeping this little peep-hole on the world. So, like Thornrose in her castle, with all her doors barred, pretty Japan, the Princess Country, fell asleep.

This settlement of the Dutchmen, however, proved to be like the tiny aperture in the dike that lets the flood come in; or as the little seed dropped by the bird that tears down the masonry; or the leaven that changes all the old, and puts in its place something entirely different. Let us see how the Dutch helped to give us the New Japan.

It was when the Dutch Republic was struggling against Spain and her mighty armies that she sent out her first ships to the far East. At first, only the Portuguese knew the sea path and had the charts. A Dutchman named De Vries, when in Portugal, made copies of the charts. Armed with these and good cannon and cutlasses, two little Dutch ships in 1598 sailed against the sun month after month until into the China seas. One of them was wrecked, but the other, named Charity, which had on board an Englishman,— one of the ten thousand then in Holland learning republican ideas,— reached Sakai, near Osaka, in 1600. The Englishman's name was Will Adams. The local governor told them to go up to Yedo. But in the bay, not far from the spot where our Commodore Perry anchored his war-steamers in 1853, the Dutch ship was wrecked. Will Adams and the Dutchmen had to get to Yedo on foot. This was the beginning of the Dutch influence on trade.

At first these Hollanders, as was natural, brought such things as butter, cheese, and the

products of their domestic agriculture. Now the
Japanese nose, to this day, cannot stand cheese,
and even yet butter is not much in demand.
Soon, however, the Hollanders learned what the
Japanese wanted, and pleased their customers by
importing instruments, medicines, and manufac-
tured articles of all sorts. They also brought silk-
worms from China. The first definite treaty of
commerce was made in 1608, and in 1609 the
great Iyéyasŭ gave audience to the Dutch captain
Krombeck, and freely granted to each Dutchman
a passport, on which were six Chinese characters,
meaning " Minamoto Iyéyasŭ permits the exten-
sion of clemency to the bearer." When the
Japanese envoys were sent by Iyéyasŭ to Holland
to confirm the treaty, Maurice, the stadtholder,
and son of William the Silent, was in camp with
his army. He received and welcomed the Japan-
ese and made them presents. Then the Japanese
understood why the Spaniards were to be feared,
and that the quarrel of the Dutch with them was
not merely on account of religion, but was for life
and country.

The Japanese were very much influenced by
what they saw, both in the camps and in the rich
cities of Holland. While their friendship with
the Dutch grew stronger, they were strengthened
in their determination to keep the Spaniards and
Portuguese out of their country. For several
years they permitted nine or ten Dutch ships to

come yearly to Nagasaki. The Dutch carried out of the country, in most lucrative trade, an immense quantity of gold and silver, with which they were assisted to keep up their eighty years' war for liberty, which gave us, the Americans, as Franklin said, " our great example." Many a Dutch skipper got rich in the Japan trade. In other towns besides Delfshaven, — whence the Pilgrim Fathers embarked for America just about the time that Will Adams died, and the Japanese were driving out the Jesuits, — one reads the name Déshima Street, in memory of old days in the far East.

When, in 1647, two Portuguese men-of-war came to Nagasaki hoping to open trade, the Japanese raised an army of over fifty thousand men to guard the city and coasts, and gathered in the harbor a fleet of nearly six hundred vessels in readiness for war, but the Portuguese ships went away quietly.

Will Adams, not being allowed to go home, married a Japanese wife. He taught navigation and boat-building, and was very popular in Yedo. The people named a street after him, which is still called Anjin cho or Pilot Street. Down on the Bay of Yedo, very near what are now the imperial dockyards, the Shogun gave him a piece of land and the revenues of a village. Here, May 3, 1620, he died, leaving one child, who did not long survive him. His tomb, with its curious

monument to himself and wife, was discovered a few years ago by an American gentleman who had read Mr. Hildreth's book on "Japan as It Was and Is." It is at Hémi, near the railway station, on the road from Yokohama to Yokoska.

In 1644 a Dutch ship was wrecked on the coast, and of the survivors three were made gunnery instructors, and two of them practiced surgery in Yedo. Lighthouses, in European style, at Uraga and Misaki, at the entrance of Yedo Bay, were built. At Nagasaki a "flint firearm fort" was built. When the Dutch merchants visited Yedo every year, many scholars, inquisitive for learning, came to them to get ideas; and in some cases books, clocks, barometers, thermometers, surveying and astronomical instruments were eagerly sought. These were the times of peace, when leisure was abundant, and some of the Samurai began secretly the study of the Dutch language. Pretty soon there were little clubs formed for study, and the government allowed chosen men to learn astronomy, mathematics, medicine, and gunnery from the Dutchmen. The first maps of the world had been brought to Yedo in 1672. Ten years later, some foreign horses were imported, and Dutchmen were employed to teach riding and veterinary science. As the years passed on, many Japanese doctors and young men, eager to know the secrets of science, openly or furtively made journeys to Nagasaki to ask questions, or get books or ideas.

The fifth Tycoon, Tsunayoshi, who ruled in Yedo from 1681 to 1708, — a period of great luxury, — and was himself a great lover of novelties, patronized the Dutch very liberally. He had them import many articles especially for his personal use. Among his good acts was the establishment of the famous University of Yedo, in which the Chinese language and literature were taught, and out of which came the great professor, Hayashi, who made the treaty with Commodore Perry.

One of the Tycoon's counselors, named Arai, was so scandalized at the luxurious habits of the time, and the money paid to the Dutch for luxuries, that he wrote a book against the prevailing fashion. In the concluding passage he computed the annual export of gold at a sum worth at the present day over four million dollars. He further declared that the Japanese could dispense with all the foreign goods except medicines.

These medicines, by the way, became very common all over the country. On most of the apothecary-shop signs I used to read the names of various Dutch nostrums, and even in the Japanese pronunciation, such as "rauda" for "laudanum," could recognize a number of ordinary European drugs. Botany was also much cultivated during Tsunayoshi's rule, and the number of students of foreign science kept on increasing.

Yoshimuné, who ruled in Yedo from 1717 to

1744, was also a great patron of the Dutchmen, and in 1725 a number of European horses were imported for his use.

One of the staples used in payment for European goods was copper. From 1609 to 1858, it is estimated the Dutch carried out of Japan two hundred and six thousand two hundred and fifty-three tons of copper, silver to the value of one hundred and forty millions, and gold to the value of seventy-eight millions of dollars. The yearly profit of the Dutch was for many years over three millions of dollars. Their annual visit to Yedo, the procession of merchants, officers, and porters numbering over two hundred persons, cost them, with the presents given to the Japanese, over ten thousand dollars.

It was not long after Yoshimuné's death that some of the Samurai in Yedo began the study of the Dutch language. Their difficulties at first were great, for their facilities were few indeed. They persevered, however, and pretty soon clubs were formed for the mastery and enjoyment of Dutch books. The translation of scientific works began to be made and published, and in that way European ideas filtered down among the people. The Dutch were quick to find that their most profitable importations were invoices of books on every branch of science. In the seventeenth century Holland led the world in learning, and the making of books. In the eighteenth they were

not far behind. The Dutch were glad and proud
to find so promising a market for their scientific
literature at the ends of the earth.

Among the scientific men of Europe who took
employment under the Dutch in order to see
Japan, was Engelbert Kempfer, who wrote a
superb book on Japan. Several of the Dutch
superintendents also were authors. In 1825 Dr.
Franz Van Siebold reached Yedo, and lived in
the great city for over three years. He stimulated
or trained up scores of bright young men to be
observers of nature, and to use their minds accord-
ing to the modern scientific method.

Yet all this time the government at Yedo re-
fused to allow the Dutchmen to have maps or
books relating to Japan, and what Kempfer and
Siebold and others obtained was by secret means.
In November, 1828, two Japanese were impri-
soned for selling Dr. Van Siebold a map. Other
natives who were found making maps on the
foreign method were punished.

Evidently there were two parties at court, and
alternately the liberal and the oppressive policy
prevailed; yet despite the fact that many Japanese
authors, artists, and scientific men were persecuted,
imprisoned, punished, or suffered death, the leaven
spread. In hundreds of cities and towns all over
Japan there were students of Dutch books, phy-
sicians who practiced medicine according to the
Western method, and thousands of men who had

visited the Dutchmen at Déshima, or had gained
a smattering of European knowledge. In this
way the prejudice against foreigners was softened,
and interpreters were trained ready for a political
change that would give them mental freedom.
Among these eager seekers after light were some
who obtained a knowledge of Christianity. Most
of the present prominent leaders of the Christian
churches, the eloquent preachers, scholars, and
writers in Japan, are sons, grandsons, or other
relatives of these early students of Dutch.

When Napoleon crushed the Dutch Republic,
the red, white, and blue flag of the Netherlands
was driven from the seas. Until the Dutch again
took Holland in 1815, there was not much trade
with Japan. From 1799 to 1809 both of the
ships arriving at Nagasaki were owned by Amer-
icans, and floated under the seventeen-starred flag
of the United States.

Owing partly to this interruption, but more on
account of the increasing severity of the Japanese
regulations and reform of luxurious habits in
Yedo, trade dwindled until it no longer paid ex-
penses. Nevertheless, the Dutch, out of sentiment
and for the honor of the flag, kept up intercourse.
In July, 1844, King William II. sent a man-of-
war with an envoy and letter advising the Shogun,
whose name was Minamoto Iyéyoshi, to open
Japan to foreign intercourse. This letter paved
the way for Commodore Perry. During the time

of the Mexican war, and of the British movements
in India and China, the Dutch kept the Japanese
well informed, advising them of the danger of
keeping their country closed, or of insulting a
nation so powerful as the United States. The
Yedo government took the good advice given,
and, through the Americans, Matthew Perry
and Townsend Harris, Japan was opened to the
world.

When those in authority finally awoke to face
the problems of modern life, they sent promising
native students to Holland, bought Dutch ships,
machinery, and munitions of war, and engaged
Dutch instructors in various departments of sci-
ence and art. When, indeed, Thornrose had rubbed
her eyes and opened her castle to all well-behaved
visitors, she made choice of English as her favo-
rite language, but the Dutch was her first love.

CHAPTER XXIV.

INTERIOR FORCES MAKING NEW JAPAN.

WHEN the Japan of our day astonished the world by abolishing feudalism, adopting the civilization of Christendom, creating a constitutional government, and becoming in most outward features a modern state, there were many who said that "the Japanese had reached in twenty years what it took other countries centuries to acquire."

The statement is no more true than to say that a nation is born in a day, or that the acorn planted this morning will be an oak to-morrow evening.

Such talk seems very foolish to the student of Japanese history. He knows that for two hundred years the Dutch seed of European civilization was growing secretly. He sees, also, other great forces, both inwardly and outwardly, undermining the system of Iyéyasŭ and preparing for the New Japan.

Among the interior agencies at work was the revival of literature. When the long wars had ceased, libraries were gathered, old records were searched, and scholars had time to study and think. One school of learned men began to

make research into ancient and mediæval history ; another studied the Shinto religion, and a third the Chinese system of ethics. Even art and the drama lent their aid to stimulating thoughts that were not favorable to the despotism of the Yedo government.

The revival of pure Shinto, which began under Mabuchi and was carried on by Motoöri and Hirata, was wrought between the years 1697 and 1843. These scholars interpreted the ancient poems and scriptures. They cultivated a taste for the native literature, and a love for " Japan as it was " before the Shogun and feudalism existed. They published books, lectured much, and had many pupils. The results of their teachings were reverence for the Mikado and a desire to see him sole ruler, and a dislike for Buddhism and the Shogun who patronized this religion. Above all, these scholars fed the burning zeal of their pupils for the restoration of Shinto as the established state church, with the Mikado as its head. Shinto meant nationalism. In provinces like Mito, Satsuma, Choshiu, Tosa, and Echizen, a party began to form that desired the abolition of the dual system of government by throne and camp, and a return to that of the early ages.

The study of ancient Japanese history was dangerous to the Shogun's authority, and a direct aid to the restoration of the Mikado. The daimio of Mito gathered a library of over one hundred

thousand volumes, and his own college of learned men. He also invited to assist, and correct the historical books which were written in the Chinese characters, the scholars who had fled from Peking when the Ming dynasty fell before the Manchu Tartars in 1627. One of these men laid out, in imitation of a classic Chinese scene, the renowned Mito gardens in Yedo, still the most famous in Japan. The tombs of other Chinese refugee scholars, who died after high honor had been bestowed on them, are near the city of Mito, about seventy-five miles northeast of Tokio. Under the second daimio of Mito (1628–1700), the new history of Japan, written in purest Chinese, and comprised in two hundred and forty-three volumes, was completed. Japanese volumes, being much smaller than ours, are easily carried. The work immediately became a standard, and was widely copied and read all over the country. Its effect on the minds of the Samurai was tremendous. It pointed out the fact that historically the Shogun was a usurper. Logically, and according to ancient Japanese law and religion, no one but the Mikado ought to rule.

The work of the men of Mito was followed up by the scholar Rai Sanyo. After digesting the contents of over six hundred books, and spending twenty years in literary labor, he published the "Nihon Guaishi," or "Japan's History Outside the Imperial Palace." Recounting the story of

the military families from the Taira to the Ashi-
kaga, he showed that every Samurai's loyalty was
to the Mikado only. The name of Rai, as a
noble exponent of literary Japan, is carved in the
granite of the Boston Public Library.

The study of the moral systems of Confucius
and Mencius also tended to make clear the fact
that the true master of Japan was in Kioto, and
that his imitator in Yedo was only a servant.
Supporters of the feudal system, with the Shogun
at its head, made especial use of the Confucian
ethics, with its central doctrine of obedience, to
secure their own authority. Yet, in the end, this
doctrine hurt the Yedo rulers. "For," thought
the Samurai, "if the Shogun is a vassal of the
Mikado, why does he not obey him?" Then they
reasoned and said, "Nay, he must obey him.
Yedo must be obedient to Kioto." Finally they
cried, " Let us, above all, reverence the Mikado,
and compel even the Shogun to obey him."

This was the way men talked long before Amer-
ican men-of-war anchored in Yedo Bay. The cen-
sorship, oppression, and cruelties, but especially
the blunders of the government, only increased
the feeling. When authors were imprisoned for
publishing books, when artists and actors were
punished for pictures and plays which fed the
rising sentiment, when scholars were nourishing
their minds on European ideas through the study
of Dutch, the dual system and the Tokugawa rule

were doomed. Before Perry's time, earnest patriots also agitated for a representative council or assembly, in which national affairs could be discussed. Such men were the reformers before the Reformation, the morning stars heralding the sunburst of 1868.

The authors, artists, scholars, and reformers imprisoned, persecuted, banished, or compelled to commit *seppuku* for their liberal opinions, or safely escaping to Europe or America, were not all of one mind. They ranged from Shintoists to Christians, and from the most fanatical and narrow-minded patriots who hated foreigners to the liberals who wanted Japan fully opened to diplomacy, commerce, and civilization.

Besides this great ferment of individual opinion, there were deep political hatreds among the great clans, especially those whose ancestors had been overcome by Iyéyasŭ. The men of Satsuma, Choshiu, Tosa, and Hizen in the southwest were especially eager to rise and overthrow the power of the Tokugawa family. No doubt many wanted a new division of spoils, but all burned to reinstate the emperor to supreme power.

The signs of the times, to those who could read them, in the year 1838, when Iyéyoshi, the twelfth Shogun of the Tokugawa dynasty, was inducted into office, were ominous. The men in power, however, could not see danger, and so in Yedo the luxury and the carousal, the processions and the

entertainments, went on. The song of the singing girl, the twang of the three-stringed banjo, the lascivious dance, the circulating wine-cup, were enjoyed as before. When the unarmed American ship Morrison, in 1839, approached Uraga, the port of entry for Yedo, to return seven shipwrecked Japanese sailors, cannon-balls were the only answer to her peaceful signals. A cowardly government, afraid of the light, insisted on killing good books and men at home, and in warning off those who might bring the torch from afar.

CHAPTER XXV.

OUTWARD AGENCIES.

So far we have looked within. Let us now see what external agencies helped to make New Japan.

In Japanese sacred legend, folk-lore, and art, the sea-monsters have much to do with the introduction of civilization. The saint rides over the waves on a dolphin, and the scholar brings pens, books, and manuscripts on the back of a finny creature. Some truth underlies these fantastic stories. In our times we may say that modern civilization came to Japan on a whale.

When the Yankee whalers of New Bedford, in Massachusetts, began, about the year 1750, to find their game leaving them, they sailed into new waters in quest of blubber and bone. They moved their ships down into South American waters. Then they rounded Cape Horn, and pushed up into the northern Pacific Ocean. Our treaties with Russia made all sub-Arctic waters free. Soon the "black ships" began to loom up in fleets along the coast of Japan.

Some of the foreseeing Samurai thought it ominous. Then they were scared. They respect-

fully remonstrated at the indifference of the government, saying the coasts ought to be fortified. Soon American sailors were shipwrecked on the coast, and had to be returned through the Dutch. Ronald McDonald, a boy born in Oregon, voluntarily left adrift, got into Yezo, and thence to Nagasaki. He taught English, and gave the Japanese some new ideas. When asked to describe the government of the United States he was told to begin at the beginning. He did so, by explaining that in America the people are king and the source of authority. This puzzled the Japanese officers. It was a long while before the American sailor boy's statement, that the people made the government, percolated through their brains.

When it was found that the North Pacific was so fruitful, the whaling industry increased mightily. Commodore Perry found that seventeen millions of dollars were invested in it. In one year, eighty-five of the "black ships," as the Japanese called our painted, smoky, and sooty whalers, were counted passing one port. Steam made the ocean a ferry, and increased the commerce to China, making also coal-supplies and open ports necessary. American ships of peace and men-of-war came frequently to Japan to take away shipwrecked sailors, or to return Japanese waifs picked up at sea. In 1846, the American sloop-of-war Vincennes, and line-of-battle ship

Columbus, came into the Bay of Yedo to ask that trade be opened. The answer from Yedo to this knock of a gloved hand was a positive refusal. In 1849 Commander Glynn, in the United States brig Preble, came to Nagasaki, and demanded in no mild terms the instant release of eight American sailors. Obtaining them, he learned that when detained in prison at Yezo these sailors had heard from their keepers about nearly every battle in the Mexican war. When California became American, and gold was discovered, the next question for the Japanese to face was this: A new neighbor had come to live just across the steam ferry. Would he not soon be knocking at their doors with an iron hand?

Thoughtful Japanese at once saw that their day of isolation was over. To say so publicly, however, meant imprisonment or hara-kiri. Nevertheless, men went on studying the Dutch books, believing that the people of America and Europe could not be such "beasts," "savages," or "barbarians" as it was the fashion to call them. About 1850, "The Song of the Black Ships," a curious ditty about the foreign sailors and vessels, resounded all over the country. Two stanzas, put in English by Professor Inazo Nitobé, are as follows: —

> "Thro' a black night of cloud and rain,
> The Black Ship plies her way —
> An alien thing of evil mien —
> Across the waters gray.

"With cheeks half hid in shaggy beards,
Their glance fixed on the wave,
They seek our sun-land at the word
Of captain owlish-grave."

On November 3, 1852, when Perry was about to sail from Norfolk, Virginia, in the steam frigate Mississippi, Mutsŭhito, son of the Mikado Koméi and the present ruler of constitutional Japan, was born in Kioto.

The whale had led the way, the American whalers followed. The war ships, now numbering a squadron, loomed up. Approaching by way of Riu Kiu, they finally entered Yedo Bay. At five P. M., on the 7th of July, 1853, four of the finest vessels of the United States navy, two of them steamers, cast anchor off Uraga. Commodore Perry,[1] the younger brother of the hero of Lake Erie, commanded the expedition. Oliver's dispatch in 1813 read, "We have met the enemy and they are ours:" Matthew's, forty years later, might have been, "We have met friends, and we are theirs."

In the treaty document, signed by Professor Hayashi, the Shogun was styled "Tycoon," or Great Prince. Two towns, Shimoda in Idzu and Hakodaté in Yezo, were made open ports for the supply of coal, provisions, and water to ships. Sailors were to be treated kindly, an American

[1] See the Life of Commodore Matthew Calbraith Perry for a full account of the American expedition to Japan.

consul might come to reside in Japan, but no trade or residence of citizens of the United States was allowed. The Japanese were now like their Sun Goddess, who opened her cave door on a crack. Perry made them presents of a model telegraph, a little steam locomotive and railway track, and a great many Yankee notions, tools, inventions, instruments, and books. On the strand at Yokohama, he gave them a grand object-lesson in Western civilization.

Now that the door was ajar, who should pull it wide open? The Japanese were surprised to find the Yankees so prompt. On the afternoon of September 8, 1856, a flagstaff was planted and the American flag was raised at Shimoda, in front of the consulate of the United States. Townsend Harris, of New York, was the consul, and Mr. Heusken was his Dutch secretary. He bore a letter from President Pierce, which he was charged to deliver to "the emperor" in person, as the Americans thought the Tycoon to be. After a year's waiting, Mr. Harris entered Yedo in triumph. In the great castle hall, before all the daimios, and in audience of the Shogun, he presented the President's letter. This asked for the opening of ports, for the residence of Americans, and for unrestricted commerce with the United States.

The great simplicity of Japanese life, even in Yedo, surprised Mr. Harris. There was little that

reminded him of European courts. He saw no
jewels, diamond-hilted swords, crowns of gold,
splendid carriages, or fine horses. Everything
seemed severely plain, and even mean, though all
was spotlessly clean. He scrupulously insisted on
all his rights as a representative of the President
of the United States, and was treated with great
respect. His life was in some danger from *ronins*,
who were "foreigner-haters," but he was never
injured, though young Heusken finally fell under
the swords of ultra-patriotic assassins.

Like a teacher at school, who gathers a class
around him to teach A, B, C, Mr. Harris spent
many months instructing the high officials of the
government in the knowledge of international
law and modern customs. Finally a draft of the
treaty was ready, and then Mr. Harris learned
that the Shogun was only a sham "emperor."
No treaty could be made unless the Mikado at
Kioto agreed to it. The coming of the foreigners
had disturbed the balance between the throne
and the camp, and the political machinery was
at once put out of order. Though the Tycoon
sent first Professor Hayashi, and then Hotta, the
Minister of Foreign Affairs, to Kioto, the court
would not yield an inch. The *kugé*, who had
never seen a foreigner, were flatly opposed to
opening the country to the "ugly barbarians."
Mr. Harris was so surprised and annoyed at the
long delay, after the Yedo officers had made and

agreed to the treaty, that he threatened to go to Kioto himself.

The long-pent-up forces now began to break out, and a national upheaval was threatened. Seeing the gravity of affairs, the Yedo government sought out its ablest man, named Ii. Thoroughly understanding the serious situation, and fearing that Japan might be conquered like India, he set his seal to the new treaty, July 29, 1858.

It is true that British and French armies were then in China, but Mr. Harris had already won the diplomatic victory without a ship or a soldier, having nothing but the American name to back him. Shortly after, treaties were made with other nations, and in 1859 the foreign settlement of Yokohama began.

The high-handed act of the Shogun in assuming the title of "Tycoon," and the opening of the country without the Mikado's consent, were taken as insults to the Mikado and the heavenly gods. Thousands of Samurai now left the service of their masters the daimios, and, floating about, became "wave-men," or *ronins*. On the 23rd of March, 1860, a party of them made an attack on the train of the premier Ii in Yedo and killed him. They now began the systematic assassination of foreigners and the burning of their legations, their object being to get the Tycoon into a war with the treaty nations. Several bloody attacks were made and many Englishmen killed, besides Mr. Heus-

ken, the secretary of Mr. Harris. The *ronins* succeeded so well that all the foreign ministers left Yedo except Mr. Harris, who kept the American flag flying. Although they called themselves Samurai, the *ronins* thought it was doing the gods service to draw their swords and cut down the "hairy barbarians." Their ardor for this cowardly business was somewhat damped when one of them, at the demand of the foreign ministers, was publicly beheaded on the common execution ground for criminals, instead of his being allowed to commit hara-kiri.

To the Americans in Japan these were dark days. At home the civil war was raging, and the Union armies at first suffered many defeats. The Alabama was sweeping the seas of American commerce, so that even letters had to be sent home to the United States on British ships.

The Yedo government, having its hands full with the foreigners, could not control the daimios and their retainers. The custom of requiring them to spend half their time in Yedo was abolished, and henceforth the gathering of the clans was at Kioto, which soon became full of all sorts of characters. Satsuma and Choshiu were among the first to take their orders from the Mikado, and to defy the Tycoon. An army sent from Yedo to chastise the Choshiu men was beaten; for the clansmen were hardy, earnest, lightly clothed, well-drilled, and armed with American rifles, while the

Tycoon's soldiers were unskillful, laced up tightly in clumsy old armor, for which they had grown too fat, besides being enervated by the long peace. The Samurai, hostile to the Tycoon, now began to unite their fortunes with the Choshiu men, who began to buy and own ships and to build forts commanding the narrow Straits of Shimonoséki. When the batteries were completed they hoisted a flag inscribed with the words, " In obedience to the imperial order," and to fire upon every passing foreign ship. The first was an American merchant ship named the Pembroke, the next a French dispatch vessel, and the third the Dutch frigate Medusa.

When Captain David MacDougal, of the United States sloop-of-war Wyoming, heard of this, he left off hunting for the Alabama and steamed into the Straits, July 16, 1863. In a brilliant action of ninety minutes, firing fifty-five shots, he destroyed one of the six batteries, sunk one brig, and with an eleven-inch Dahlgren shell blew up a steamer; returning with a loss of six men killed and seven wounded. A few days later, the French landed and destroyed a battery, but the Choshiu men still held the forts.

About this time an attempt was made by a large body of men from the same clan to capture the imperial palace in Kioto, and carry off the Mikado, so as to clothe the acts of Choshiu with his sacred authority. The plot failed; a battle

ensued, in which many men were killed, and thirty thousand houses in Kioto burned. It was a strange sight to see men dressed in armor loading and firing cannon. The soldiers of Echizen and Satsuma were honored for defending the palace, and the Choshiu clansmen were forbidden ever again to enter Kioto.

Near Yedo, while the procession of the daimio of Satsuma was passing along the Tokaido, a party of English travelers were riding along, and not thinking of dismounting, as the natives always did, braved danger and rode on in the face of the train. Taking this as an insult, the Samurai cut down the three tourists, wounding two and killing a third, Mr. Richardson. For this act a British fleet bombarded Kagoshima, the chief city in Satsuma. They also demanded and were paid an indemnity of five hundred thousand dollars from the Tycoon, and twenty-five thousand dollars from the Satsuma clan.

In September, 1864, the combined squadrons — seventeen war-ships — of four nations — British, French, Dutch, American — destroyed the forts at Shimonoséki, "cleaned out the den," and compelled the Yedo government to elect between paying an indemnity of three millions of dollars and the opening of new ports. The first alternative was chosen, and the treasury in Yedo was nearly exhausted, even by the partial payment.

The southern clans, thus severely chastised by

the foreigners, learned wisdom. They resolved to unite to beat the Shogun and restore the Mikado to his ancient authority. Their plan was the one common in all Japanese history, to get hold of the Son of Heaven, and to proclaim a new government in his name. Matters hastened to a crisis. Early in 1867 the old emperor died, and the young and now reigning Mikado took office. By the force of public opinion, which demanded a return to the ancient system in force before the days of Yoritomo, the Shogun resigned November 9, 1867. A council of the daimios was appointed to meet December 15th to arrange for the formation of a new constitution, but it failed to meet. Meanwhile Kioto was filling up with armed men, especially from Satsuma, and a coalition of clans was formed for the service of the palace. On the first of January, 1868, Hiogo and Osaka were opened to foreign trade amid naval and military display, the firing of salutes, and the raising of flags.

In Kioto, on the 3d of January, 1868, the "Mikado reverencers" having obtained an order from the court, the troops of the coalition seized the palace gates, and a new government was established on the ancient foundation. The Tycoon was greatly surprised and enraged to find the palace in the hands of his enemies, and secretly left Kioto on the night of January 6th, going to Osaka, where he received the visits of the foreign ministers, who were puzzled to know with what

government they were to treat. Yielding to the advice of his followers, he advanced at the head of several clans still loyal to him against the city of Kioto, to deliver the young Mikado from his advisers. By order of the court, he was forbidden, and declared a *cho-té-ki*. The "loyal army" marched out to fight him.

The civil war opened by a battle at Fushimi, near Kioto. The Tycoon was beaten, and fled by sea to Yedo. He soon after retired to private life, first in Mito and then in Shidzuoka, where he still lives quietly. After campaigns in the north, and various battles, the imperial armies were everywhere victorious and peace again reigned.

One of the first acts of the new government was to ratify the treaties in the name of the emperor. For the first time, the name of a Mikado was made public and shown in a signature. Then the emperor took an oath to establish a national assembly, to decide measures by public opinion, and to abolish uncivilized customs. This oath is the foundation of the constitution of New Japan. The capital was removed to Yedo, which was named Tokio. From this time, this great city became the political and intellectual centre of the national life.

CHAPTER XXVI.

NEW JAPAN.

SEVERAL years before the fall of the Yedo government, parties of young men got away secretly from Japan to study in the United States and Europe. In the autumn of 1866, the writer of this little book, when a student at Rutgers College, New Brunswick, N. J., met the first Japanese lads who came as students to that city. Many others followed these two, until there were scores of them at work mastering the language and the sciences. By November, 1869, the writer had met hundreds of the men of New Japan who had come into the wonder-world of Western civilization. With a score or so of them he was well acquainted. From these he learned much of Japanese history and home life, especially from one Sugiura, of Satsuma; and Kusabé, of Fukui, in Echizen.

Dropping the third person, let me say that it was to this latter province and city that I was invited by the daimio Matsudaira, Echizen no Kami, and his officers. Shortly after graduation from college in the summer of 1869, I left for Japan to organize schools on the American prin-

ciple and teach science. I arrived at Yokohama December 29, 1870, and in Yedo, now called Tokio, January 2, 1871.

Here, in the capital, I remained seven weeks, meeting several of the great daimios and many officers and Samurai who had been active in the Restoration. The city was then full of soldiers and rough characters, and it was uncertain as yet what kind of a country New Japan was going to be. Everything seemed to me as strange as moon-land or the under-sea world. The Samurai all wore swords and top-knots, and many of them scowled at the American; the processions of the daimios were gay and full of fuss and show; the *kugé* had black teeth, spotted foreheads, and brick-shaped hats; the Eta, or pariahs, were still treated as beasts in human form; and everything was strange, lovely, or horrible. It was Old Japan almost unchanged.

From Tokio, by kago, jinrikisha, horse, steamer, and on foot at times, I made the journey on sea, river, lake, and land, by way of Kobé and Osaka, to Fukui. From March 4 until January 22, I saw life in a daimio's castle town; and during most of this time I was entirely alone, and hundreds of miles away from a white person. The feudal system was in practical operation until October, when the daimio in the great hall of the castle bade a solemn farewell to his retainers. Over the snowy mountains, in January, I made a journey of eleven days to Tokio. Except occa-

sional journeys to near or distant places in Japan, I remained in the capital until July, 1874. Let me here summarize what I saw : —

1. The Emperor no longer living invisible like a god, but appearing in public.

2. The government in the hands of men of European ideas, who had been educated in the Dutch or the English language.

3. Feudalism abolished, and all the daimios called to live in Tokio, about three hundred petty little governments becoming one.

4. The old adherents of the Shogun, and the members of the Tokugawa family, pardoned and restored to honor ; the country at peace.

5. National systems of law, justice, money, postal service, education, banks, lighthouses, railways, telegraphs, taxation and revenue, with an army, navy, treasury, organized for the service of the nation.

6. All rebellions against the national government speedily suppressed, and order maintained over the whole empire, including Riu Kiu and Yezo.

7. All claim upon Corea as a military nation given up, a treaty of peace and commerce being afterwards made.

8. A most wonderful change in the dress, food, ideas, habits, and customs of many of the people, and the general adoption of the outward features of the civilization of Christendom.

9. The persecution of Christians stopped, and the public edicts threatening punishment removed; Christian schools and churches organized.

Before leaving Japan I had the pleasure of meeting the Prime Minister and most of the members of the Cabinet on their return from the embassy sent by the Emperor round the world to study the civilization of the United States and Europe. Besides seeing his Majesty many times in public, I enjoyed the pleasure of an audience in the imperial palace, New Year's Day, 1873.

The chief events since 1874 have been those leading to the promulgation of the written constitution of February 11, 1889, under which Japan is now governed. New orders of nobility were created. The old names of *kugé* or court noble, and *daimio* or landed noble, and most of the old titles and offices, were abolished, and the two classes merged into one under the name of *kuazoku*, or "flowery nobility," with several ranks. The Samurai, now called *shizoku*, gave up wearing swords, and relinquished their hereditary incomes, paying taxes like the common people; the latter being admitted to the privileges, under restrictions, of voting for and in the local and national assemblies, and also of serving in the army and navy. The various classes below the *shizoku* were made one, the *hei-min*, or people. The land-tax was first equalized and then reduced. Local government was introduced into

all the *ken*, or prefectures, the Christian missiona-
ries and native churches doing very much for the
education of the people in parliamentary order.
The number of public officers and underlings was
greatly diminished. In a word, government be-
came national and uniform.

Among the people, taste for foreign architec-
ture, furniture, dress, food, and social manners and
amusements greatly increased. There were also
crazes or manias for things imported from across
the ocean. Rabbits, pigs, cock-fighting, waltzing,
spirit-rapping, wrestling, fencing, and a variety of
ridiculous notions came in vogue, each for a short
season. The waves of excitement and desire for
novelties flowed and ebbed. The Japanese showed
themselves as crazy as excited Americans often
are over the fashionable phantoms of a day. In
every instance came the inevitable reaction, and
native customs, amusements, dress, ideas, and
things of the older time ruled the day again, for
a while only, in their turn to pass away. Japan,
by incessant change, made up for three centuries
of rigidity. The changing tides of fashion set
in and went out so rapidly, and often so vio-
lently, that one would think Queen Jingu was still
playing with the jewels of the ebbing and flowing
ocean-tide, fooling the Japanese as she fooled the
Coreans.

The greatest event in modern Japan was the
giving of the constitution of February 11, 1889.

This took place almost exactly twenty-five years after Perry's second visit to Japan and the calling of a great council of daimios in Yedo to decide on the opening of the country to foreign intercourse. The day was one of popular rejoicing, probably exceeding anything ever known in the empire. Posthumous honors were bestowed upon the " Morning Stars of the Restoration," and especially upon those who had, in years gone by, advocated representative assemblies.

Government under the new constitution is modeled after that of Germany, rather than that of Great Britain. The Cabinet ministers are responsible to the Emperor, and not to the Diet. All the people are equal before the law, and are granted the rights of conscience and most of the privileges of people in Europe. The Diet meets in two handsome edifices built in modern style, with chairs, clocks, electric lights, telegraphic facilities, and newspaper reporters, and is conducted in European fashion. The upper house consists of about three hundred nobles and persons nominated by the Emperor. In the lower house, the three hundred members are elected by voters who pay fifteen dollars of national taxes. The chief work of the Diet is to express the public opinion of the country, and to shape the general policy of the government. From 1868 until 1890, so many members of the three clans of Satsuma, Choshiu, and Tosa filled the high offices that people called

the government "Sa-cho-to." This monopoly of
office and power has now passed away.

With her changed ideals of civilization, hearty
acceptance of modern principles of law and jus-
tice, with her railways, telegraphs, lighthouses,
schools, colleges, postal and money systems, Japan
now asks to be acknowledged and received by the
treaty powers as an equal among civilized nations.
With her constitution, granting liberty of con-
science to all subjects of the Emperor, and with
her increasing Christian population, the day can-
not be distant when tardy justice will be meted to
her.

Shall it be given? Americans all, Townsend
Harris [1] and the missionaries first, then teachers,
merchants, and the government at Washington,
have long ago voted " Yes."

In the Centennial Exposition at Philadelphia
in 1876, in the rotunda of the main hall, a poem
in *hira-kana* was painted in large letters. It was
written a thousand years ago. We translate it as
follows : —

> "In the ancient Yamato island, the sun rises:
> Must not even the foreigner reverence ?"

These two questions have been answered, and
first by the English-speaking peoples. Japan,
now one of the great Powers of the world, is

[1] See his life and work in *Townsend Harris, First American
Envoy in Japan.* Boston, 1895.

recognized as belonging in the fraternity of civilized nations. After twenty-two years of protest, appeal, and discussion, the Japanese have won their case. On the 26th of August, Lord Kimberly and Viscount Mutsu in London, and on the 22d of November, 1894, Secretary Gresham and Minister Kurino at Washington, signed new treaties. These abolish extra-territoriality, and consular courts in Japan, and acknowledge Dai Nippon as sovereign and equal.

Without waiting to be impressed by the military strength displayed in the war with China in 1894–95, Great Britain and the United States acted justly and honorably. The American treaty was ratified December 8th, and will go into operation before the dawn of the twentieth century.

OWARI.

INDEX

Lightning Source UK Ltd.
Milton Keynes UK
UKHW020616030323
417973UK00008B/793